First published 2007 by
Liverpool University Press
4 Cambridge Street
Liverpool
L69 7ZU
www.liverpool-unipress.co.uk

Distributed in Canada, Mexico and the USA
by University of Chicago Press
www.press.uchicago.edu

British Library Cataloguing-in-Publication
Data
A British Library CIP record is available

ISBN 978-1-84631-120-8

Designed by 2020 Design, Liverpool
Set in Gill Sans

Printed in the European Union by
RAP Spiderweb, Manchester

This publication has been funded by the
Arts and Humanities Research Council of
the United Kingdom.

Contents

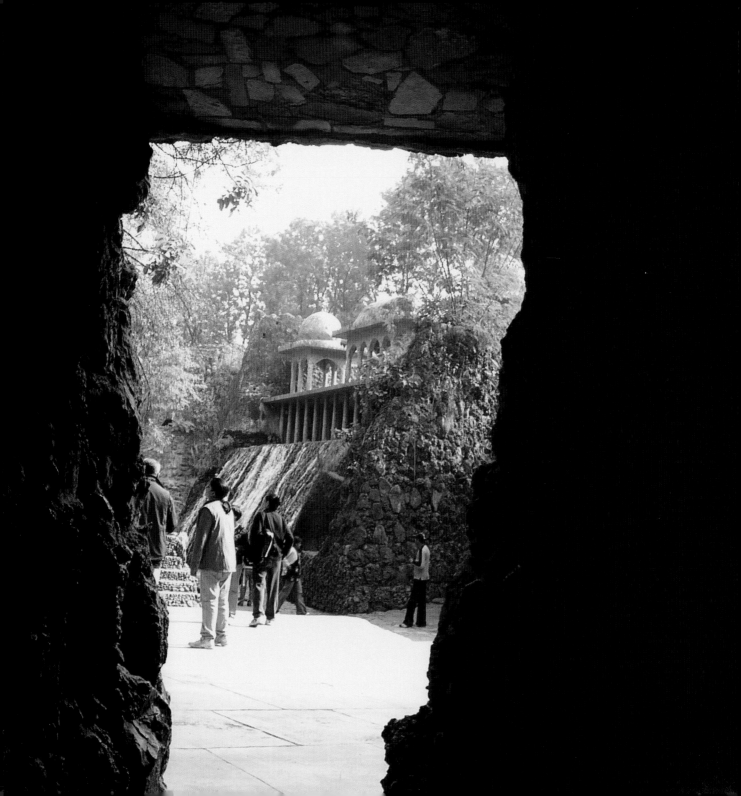

Preface

Nek Chand's Rock Garden holds a unique position in the context of its location, Chandigarh, the Indian city commissioned immediately after Independence in 1947 – master-planned and designed along Modernist thoughts by Le Corbusier, the renowned Swiss-French architect. It occupies the northern perimeter of Chandigarh, immediately east of the administrative hub of the city, the Capitol Complex. There, Nek Chand, a road inspector with the city's Public Works Department, made the humble and secret beginning of the Rock Garden in the late-1950's. His initial interest in collecting rocks with suggestive forms from the nearby riverbeds to create a personal world of dreams and fantasy gradually expanded into the production of sculptures using discarded household objects and industrial waste. Scouring the dumping yards of Chandigarh, Nek Chand worked unnoticed to produce an ever extending collection of sculptures, landscape and fascinating architecture. Following a period of uncertainty, the Rock Garden was granted formal recognition in 1976 and allowed to exist within the official jurisdiction of the city, contrasting and contradicting nearly every aspect of Chandigarh's architectural, urban and aesthetic agenda. In its almost fifty years' existence the Rock Garden, which contains thousands of artefacts spread over 18 acres of land, has grown to become one of India's foremost tourist attractions. The Garden, sitting within a context configured and produced by a specific brand of high Modernism, has drawn from a diversity of Indian traditions and histories on the one hand, as well as, from Modernism and Postmodernism on the other. In more recent years Nek Chand, now in his eighties, and his Rock garden have received governmental and foreign assistance and the help of a small workforce who continue to work under his instruction. Despite its immense popularity, the Garden had hardly received any academic attention,

while the Modernist creations of the city continued to ride high on the agendas of the academic and architectural circles.

This catalogue, accompanying an exhibition of the same title, results from an Arts and Humanities Research Council (AHRC) funded project to document, analyse and study Nek Chand's Rock Garden. This is the first attempt to look at the work from an academic perspective with an additional aim to achieve a wider dissemination of the material. For this, the catalogue has been deliberately kept short, deciding to highlight only the most important aspects of the Rock Garden and the key findings. It is our aim to publish in the near future a detailed monograph containing a comprehensive catalogue and interpretation of all artefacts, architecture and landscape features. Prior to this research the physical make-up of the Rock Garden was an unknown factor as Nek Chand, understandably, worked entirely without plans and only rough estimates

were made with regard to the quantity of sculptures produced. Following on from a detailed documentation the project has sought to identify the creative influences on Nek Chand's work, its deeper mythological and cultural underpinnings, as well as, the continually changing politicised relationship between the city and the Garden.

Many individuals and institutions have made the project possible. A very special thank-you should go to Nek Chand Saini for his generosity and help with this research project. Without the use of the 'guest-house' and the support for this project much of it would not have materialised. Also thanks to Roohi Kalia and Anuj Chand Saini for their support, guidance and friendship whilst staying at the Rock Garden. We would like to thank the AHRC for providing generous funding support for the study and the Liverpool School of Architecture, University of Liverpool for hosting the research project. The exhibition

and this catalogue were made possible by an additional grant from the AHRC. Generous support towards the exhibition has come from the Renew Rooms of the Royal Institute of British Architects (RIBA), Raw Vision Magazine, Entwistle Reprographics, Liverpool University print room and Liverpool University Press.

Fieldwork was conducted by Iain Jackson as part of his doctoral studentship funded through the AHRC project. Much of the photographs and all drawings, as well as the production of QuickTime VR model, have resulted from Iain's unstinting engagement with the project and the desire to make it happen. Iain also shot the film that accompanies this exhibition, shot on location in March 2006.

The field trips to the Rock Garden were made possible through Julia Elmore, Maggie Maizels and John Maizels of Raw Vision Magazine and the Nek Chand Foundation,

UK, all of whom we thank for their consistent and relentless support of this project. Also thanks to John for writing the foreword to this catalogue. Thanks are due to Jo Jackson for helping to survey the (countless) sculptures in 2004 and the remarkable photographs of Nek Chand and Chandigarh. The fieldwork was supported by students from the Liverpool School of Architecture. The initial survey drawings and material for the QuickTime VR models were prepared in 2005 by Neal Dunne, James Richardson and Ninnie Yeo, with special thanks to David Shanks for his wide-ranging contribution to data collection and the QuickTime modelling. The 2006 team comprised Chris Barker, Sarah Christianson, Jessica Daly, Jessica Howard, John McNally, James Patterson-Waterston and Antoinette Stephens-Woods. Many thanks to the donors of the Nek Chand sculptures for allowing us to display these unique art works – all the sculptures were produced by Nek Chand and his team in Chandigarh

and have not been exhibited outside of India before.

Thanks are also due to David Stokes for his active help and advice towards the exhibition, and Alexandra Williams, Marc Atanes, Mat Critchley and Stuart Carrol of the Liverpool School of Architecture in making it happen. Thanks are due to Phil Berridge and Gareth Higham of 2020 Design for their advice and design of the catalogue. The two photographs of Indira Gandhi at the Rock Garden and the 'human shield' are courtesy Nek Chand and the Rock Garden archive. Marg, the longstanding Indian journal of art, has generously allowed the reproduction of the two photographs on the collection of found objects and art of Le Corbusier and Pierre Jeanneret in this catalogue.

Finally we would like to thank our families, Jo, Jagori, Trina and Rishi for putting up with our madness!

Nek Chand

The untaught genius who built a kingdom

The roots of Nek Chand's extraordinary creativity stem from his childhood. From the building of fantasy mud cities by the side of a river bank, from the stories of wondrous kings and queens told to him by his mother, from dolls and figures made from broken bangles found on the ground by market stalls, from colourful scarecrows to ward off birds from his father's crops.

These early creative experiences in the idyllic Punjabi countryside received an almighty jolt with the 1947 partition, the parting gift of the British to their former subjects. Along with his Hindu family Nek Chand lost his home, his farm, his village. After a three-week trek through desert his refugee column eventually found respite and through a special employment programme, Nek Chand was given work in the construction of the city of Chandigarh, the new capital of the half of the Punjab remaining in the new India.

Acting as an inspector of road construction he supervised teams of workers, was charged with collecting the debris of 24 villages demolished to make way for the new city and observed the methods of the master architect, Le Corbusier, whose great project it was.

These three strands of Nek Chand's experience: his childhood, the loss of Partition and the Corbusier/Chandigarh construction, combined to make the man he became. His first secret effort to create a garden, hidden deep in forested government land, was a recreation of his lost village home. His first sculptures were a reaffirmation of his childhood creations and his grand designs of landscape architecture used the sophisticated construction methods of one of the twentieth century's greatest architects, along with the recycling of much of Chandigarh's waste. Combined with his uncanny ability to manage people, to turn humble workers into skilled

craftsmen, to attract the support of the powerful and influential, he was able to build one of the world's most astounding creative achievements of modern times.

The Rock Garden, as it was named by the Chandigarh government, is in fact a private kingdom, an earthly paradise of rushing streams and great waterfalls, leafy trees and deep gorges, twisting walkways that suddenly open up into expansive spaces. All this peopled with countless sculptures of kings and queens, beggars and ministers, schoolgirls and schoolboys, revellers and dancers, monkeys, elephants, camels, horses, dogs and deer.

Nek Chand's great genius is there for any visitor to the Rock Garden to experience. His many years of solitary toil developed into a massive construction programme once the Chandigarh Administration had given their support. His initial creation, illegal and clandestine, could so easily have been destroyed by the authorities, as would have happened in most cases, in most countries; but India, certainly in the few decades after independence, was different. His creativity was something to rejoice, his innate spirituality something to respect and above all the humbleness of a great man brought humility on all in the face of such astounding achievement.

John Maizels
Editor of Raw Vision Magazine and founder of the Nek Chand Foundation

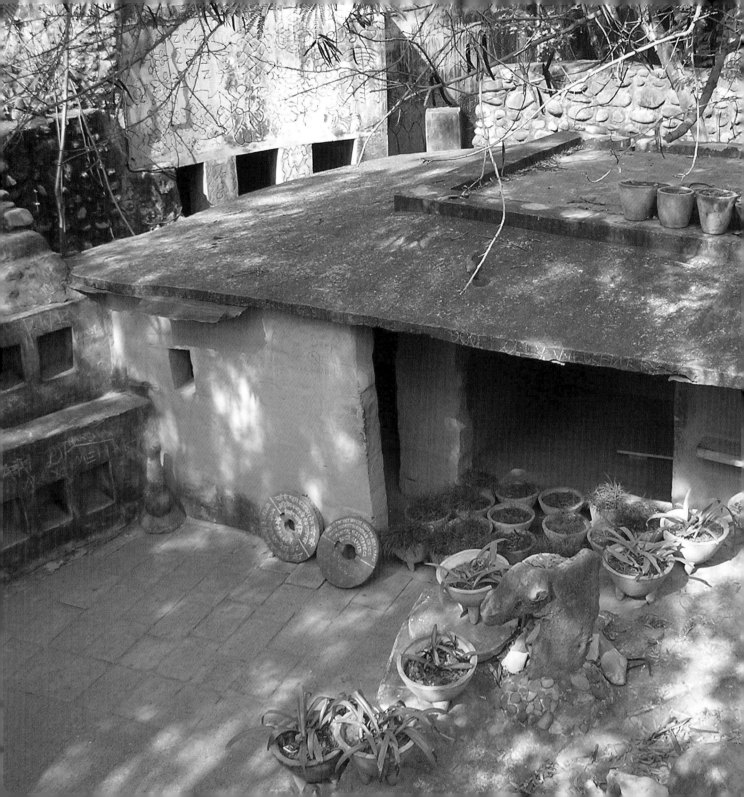

Introduction

Pre-clandestine memoirs

Nek Chand Saini was born on the 15th December 1924, in a village called Barian Kalan, near Tehsil Shakargarh (Aulakh 1986: 12). At the age of twelve he was sent to live with his uncle in the Gurdaspur region attending the Ghulam Deen Mangri High School, where he was educated up to matriculation and left in 1943[1]. Upon returning to his village he began working on his father's farm. Following India's Independence from Britain, the Act of Partition divided the nation and as a Hindu, Nek Chand and his family left their village, located in what was by then Pakistan and moved into the Indian territory. They went to Jammu and tried to settle in Gurdaspur.

Nek Chand took advantage of a Government programme to employ refugees and moved with his wife to Chandigarh. He started work on Chandigarh Capitol Project on the 10th October 1950 as a road inspector with the Public Works Department (PWD), and continues to reside in the city.

Tales about the man behind the garden

Shortly after the Sukhna Lake was excavated in 1958, Nek Chand began making rafts and vessels to sail upon the lake. After this was banned by the official sailing club and peddle boats were made available for rent, Nek Chand devoted more time to his passion for natural rocks and stones. It was around this time that he began to actively occupy a piece of land beside the PWD stores he was in charge of. The land was located near the High Court building in Sector-1, at the northern edge of the city, and is the current site of the Rock Garden. The stores were set back from the road and provided Nek Chand with ample material, space and eventually labour, which he would use to develop a

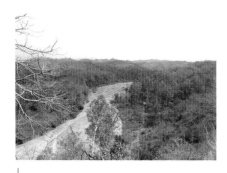

|

small patch of land. He formed a collection of rocks, gathered from the Shivalik hills and the seasonal Sukhna Cho, Patiala Rao and Ghaggar rivers. Figure-2 shows the location of two of the rivers relative to the position of the Rock Garden by Sector-1. The largest river Nek Chand quarried is the Ghaggar (**1**), approximately eight miles from Chandigarh that Nek Chand would visit on his bicycle.

In addition to the rocks other materials were also collected. The material came from the villages destroyed to make way for the new city of Chandigarh (**2**)[2]. Certain fragments of these villages caught Nek Chand's eye and he began actively searching and collecting particular discarded objects. These fragments were the remains of the villages, and consisted largely of everyday mundane possessions such as broken pots and bottles. Sometime in 1965 a more conscious effort was made to transform the found fragments and to arrange the rocks

into a formal display (Bhatti 1989). The site was also in a dense area of vegetation and needed to be cleared. Concrete and mud flooring was prepared and initial structures made up of oil drums and iron shuttering were constructed. With the PWD stores acting as a suitable decoy, an alternative Chandigarh was being constructed behind the shuttering and the scrap materials. The PWD stores provided Nek Chand with a free supply of cement, bitumen, steel reinforcement bars and oil drums that he needed to develop the site. He was also able to second labourers associated with building the roads, to work on his project instead (Bhatti 1982: 224 & 234). The massive construction site that was Chandigarh provided a suitable cover for Nek Chand's covert hobby. After four years work involving daily commitment to the project working evenings and 'by the light of burning tyres' (Bhatti 1982) – perhaps indicative of the later mythologisation of his covert activity – Nek Chand started

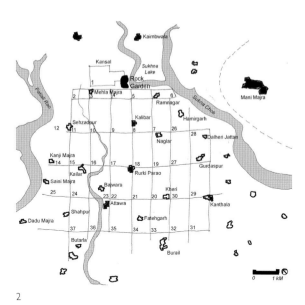

2

to become nervous about his actions[3]. It was possible that his employment could be terminated should his garden be discovered. However, this awareness did not stop the project or prevent Nek Chand from building and expanding the garden.

Creation myths

At this point sometime in 1969 Nek Chand decided to visit the city's chief architect, MN Sharma, a disciple of Le Corbusier, who was initially too busy to see Nek Chand, but following his persistence, Sharma agreed to meet him one Sunday and was taken to the garden. Although Sharma should have arranged for the garden to be demolished, he claimed that his admiration for the work and Nek Chand's 'creative potential' conflicted with his position as Chief Architect and Secretary of Chandigarh Administration. In a Raw Vision article Sharma wrote that he, 'didn't have the heart to go by the rules and advised him

to continue his work in secret. I made up my mind to help him get recognised, and although it took a year or so, I fulfilled my promise in 1972' (Sharma 2001: 28). It was an unusual position for the architect to take. In 1969 the garden would not have been very large; the structures more akin to garden sheds and the displays were of a small scale made up of natural components. On the other hand, as a new and busy Chief Architect, why would Sharma object to a road inspector decorating and improving the area around the PWD stores? He probably was not aware of Nek Chand's ambition for the site and the informal sanctioning of the work accelerated Nek Chand's production rate.

The creation stories of acts such as the making of secret gardens are always wrapped in mystery, as there always are diverse speculations on alternative origins and claims to authorship and discovery rights. The Rock Garden is no exception.

In Bhatti's story of the Rock Garden's discovery there is no mention of MN Sharma and his Sunday afternoon visit to the garden in 1969. According to Bhatti, the garden was discovered by a team of government malarial research workers, under the direction of Dr. SK Sharma, the Assistant Director of Chandigarh Administration Health Services on the 24th February 1973 (Bhatti 1982: xvii). This is also the official story of the Rock Garden souvenir booklet produced by Chandigarh tourism. SK Sharma claimed he was, 'very much impressed to see such a hidden art treasure' (Bhatti 1982: xx) and informed Dr. MS Randhawa. MS Randhawa was the first Chief Commissioner of Chandigarh and part of the Indian Civil Service who was instrumental in the landscaping of Chandigarh as well as securing its art collection. On the 23rd June 1973, as Chairman of the Chandigarh Landscape Advisory Committee he recommended that the garden be saved and, 'preserved in its

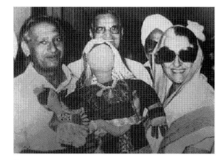

3

present form, free from the interference of architects and town planners' (Bhatti 1982: xx; Aulakh 1986: 21)[4]. MS Randhawa named the site 'The Rock Garden', but in a later interview Nek Chand said that this was not what he had in mind, 'it's a child's dream and not a garden of cold rocks ... it is my poetry with rocks' (Tribune-news-service September 2 1996). Bhatti has remained adamant that it was only after 1973 that MN Sharma became involved and that Randhawa made the final decision because of the landscape nature of the project[5].

Formalisation and remote curiosity

Between Randhawa's declaration and the inauguration by Chief Engineer Kulbir Singh on the 24th January 1976 (**3**) there is a gap of over two years. During this time Nek Chand continued working on the garden producing sculptures, with the positive support of the then Chief Commissioner TN Chaturvedi[6]. 'Phase-2' of the project

was also completed during this time, which contains most of the sculptures currently on display[7]. The exact layout of the garden at this time is unknown, however by 1980 a perimeter wall was constructed and all of phases one and two, including the café were complete in the layout we find these presently[8]. The café was designed in conjunction with MN Sharma, at the request of Nek Chand (Sharma 2001: 28) and a commemoration plaque is positioned in the café entrance to mark the collaboration. Following the declaration in 1973 labour was made available to prepare the garden for the opening. TN Chaturvedi suggested that Nek Chand be released from other 'mundane duties' and made the 'creator-director' of the garden to work on it fulltime[9].

The Rock Garden grew immensely in popularity during the 1980's with Nek Chand receiving the Padam Shri in 1983 and one of his sculptures appearing on

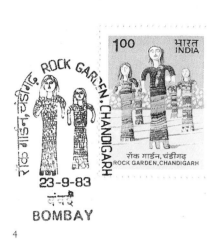

4

5

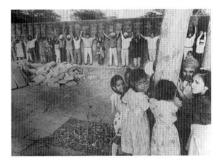

6

Indian postage stamp (**4**). Nek Chand also began receiving attention from outside of India and was awarded the Grande Médaille de Vermeil in Paris in 1980, following an exhibition held in Paris. After a visit by Ann Lewin, the Director of the Children's Museum in Washington DC, to the Rock Garden Nek Chand was also requested to construct a garden at the Museum. Nek Chand accepted the commission for which work started in 1986 with sculptures exported from India (Crosbie 1986)[10].

Demolition attempts

An estimated 2,000 visitors enter the Rock Garden daily, many travelling long distances from all over India and abroad (**5**). Despite the success and popularity of the Rock Garden, it was in danger of partial-demolition in 1988 when the High Court applied for permission to demolish the embryonic Phase-3 to make way for a 'Botanic park' linking the car park of the

court to the Sukhna Lake (The-Tribune-Bureau April 21 1990). In a Times of India article, Nek Chand mentioned that the former advisor to the Administrator, Ashok Pradhan had deliberately initiated the botanical garden scheme to truncate the Rock Garden. The Bar Association argued that the 'expansion [of the Rock Garden] violated the Masterplan [of the city] and sought to encroach on land earmarked for the High Court' (Bhardwaj November 4 1991)[11].

Following outcry from the city's residents and a court appearance by Nek Chand, the petition was unconditionally withdrawn by the Bar Association with the final ruling on the 18th October 1989 (Ahmed October 20 1989). However, further attempts were made to demolish the garden, this time to make way for a road to Kaimbwala village just north of the Sukhna Lake. The road would have reduced the travel distance to the village by only 'two hundred yards'

THE TRIBUNE TUESDAY, FEBRUARY 16, 1993

Editor's mail

Facts about Rock Garden

I want to share with the people of Chandigarh the facts I have gathered on the expenditure being incurred on the development and maintenance of the parks and other open spaces in the city by the UT Administration. There are also figures of the expenditure incurred on the development and maintenance of Rock Garden during the past three years. A comparative study of the figures should help dispel the myth of Rock Garden eating up a major chunk of the annual allocation:

Rock Garden	1989-90	Rs	25.63 lakh
	1990-91	Rs	39.57 lakh
	1991-92	Rs	19.32 lakh
Development of	1989-90	Rs	33.80 lakh
parks and other	1990-91	Rs	39.57 lakh
open spaces	1991-92	Rs	36.25 lakh
Maintenance of	1989-90	Rs	96.24 lakh
parks	1990-91	Rs	107.96 lakh
	1991-92	Rs	135.42 lakh

The figures make it clear that the Chandigarh Administration is utilising more than 80 per cent of the expenses under the common head "landscaping" for the development and maintenance of parks and other open spaces.

Interestingly, in spite of spending such huge amounts every year on the parks and other open spaces, we cannot see any single park well maintained or worth talking about. In comparison, only 20 per cent (roughly) of the allocation is being spent on the development and maintenance of Rock Garden, and it is a permanent feature of the city which will not require huge funds once its development work is completed. It should be noted that Rock Garden is also generating its own revenue – between Rs 3 lakh and Rs 4 lakh – by way of the sale of entrance tickets.

NEK CHAND SAINI
Chandigarh

(The-Tribune April 24 1990). Bulldozers were sent in to start the demolition process on the 20th April 1990, but 'human shields' encircled the site protecting it from the machinery (The-Tribune-Bureau April 21 1990) (**6**). Following a discussion on the issue in the State Assembly, the route was altered and this also resulted in Pradhan's transfer to another department. Nek Chand took the event as a personal attack claiming that the whole episode, 'was done to humiliate me' (Bhardwaj November 4 1991). All these events were 'played out' in the local media.

Progress on Phase-3 (1983 onwards) was delayed by a lack of resources and the opening ceremony was postponed due to incomplete work (Express-news-service October 7 1992) and substandard cement (The-Tribune March 29 1992). The garden also came under attack over the large amounts of finance the city was providing to develop the latest phase. Nek Chand

frequently replied to such criticism in the press, citing figures and expenses incurred (Chand February 16 1993) (**7**)[12]. It was not until the 23rd September 1993, that Phase-3 was inaugurated by Ramesh Chandra, Advisor to the Administrator (Tribune-news-service September 24 1993, see also the plaque at the entrance to Phase-3). The third phase was, however, incomplete at the time of the inauguration, and remains so to date. Shortly after the inauguration Nek Chand featured in the local papers asking the Administration for additional funds and support to complete the work. In an unusual reversal Nek Chand became 'the client', demanding the work be completed on time, even challenging the city's chief engineer (Express-news-service June 14 1992; Express-news-service October 7 1992). The local papers also reported on the delays and the lack of progress with headings such as, 'Whatever happened to Rock Garden-III' (Parihar February 9 1993; Chandigarh-Newsline February 16

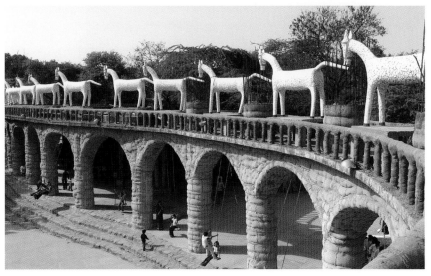

8

1994). There have also been problems with the aquariums in Phase-3 which still leak, Nek Chand blamed the city engineers for providing incorrect calculations (Singh September 12 1996). The garden has also faced some criticism over the latest phase, mainly with regard to the lack of recycling and a shift away from the intimate spaces of the previous two phases (Parihar April 22 1992; Saxena November 18 1995). The main concept of the Rock Garden is remaking art out of junk, yet Phase-3 contains very little recycled material and considerable steel and cement.

Works damaged

The main concern of Nek Chand during the last ten years has been a lack of maintenance coupled with staff shortages. This has led to dilapidation and resulted in damage to some of the sculptures. During the 1990's when Nek Chand was increasingly away from the Rock Garden

on foreign visits the Administration would remove the garden's workers, who are still employed by the PWD, onto other duties around the city leaving the Rock Garden without adequate staff. The Rock Garden staff act as security and prevent the visitors from climbing on the sculpture podiums, as well as helping Nek Chand make the sculptures and buildings. Without their presence several sculptures were damaged and there were allegations that the sculptures may have been deliberately vandalised (Menon August 3 1997; Chandigarh-Newsline July 20 1996; Chandigarh-Heartbeat Nov 19 1993)[13]. The lack of maintenance has resulted in some of the works not receiving adequate care and becoming weakened as a result. It should also be stressed that the metal armatures of the older sculptures are recycled, which are often rusty and likely to perish in the extreme conditions of the region. The cement is not of high quality and of insufficient cover to protect the metal

reinforcements from rusting within. When the sculptures are this vulnerable they are particularly susceptible to damage by visitors handling or sitting on them.

Following the damage sustained whilst Nek Chand was away, Raw Vision Magazine published a full page statement asking readers to write to the Prime Minister and President of India to support the Rock Garden. Nek Chand replied in an open letter to the readers of the magazine, an excerpt is below,

> 'My worst enemy is the top bureaucrat of Chandigarh, Mr. Pardeep Mehra, Advisor to the Administrator. Although he is supposed to have complete control over public property he never visits the Rock Garden, even though he goes to every nook and corner of Chandigarh. Three times I have tried to see him and on each occasion

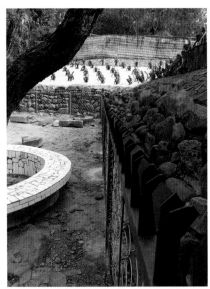

9

he has kept me waiting outside his office for over two hours and still claims to be too busy to see me. He and others in the I.A.S. (Indian Administration Service) have done everything to hinder the progress of the Rock Garden. Since 1988 work has only been able to continue in fits and starts, depending on the fancies of administrative officers. I have seen that any sympathetic official is soon transferred elsewhere. It is a pure burning red jealousy, defying all the norms of rationality. They will not even allow me to use the entrance money for the maintenance of the Garden and now there are no funds at all to finish the construction'.

The damage in the garden prompted the formation of The Nek Chand Foundation in the UK and later in the USA, with the aim of preserving the garden and encouraging its development[14].

It is only in the since 2004 that work on Phase-3 has recommenced, with new floors being laid and large sculptures being installed on top of the 'family-sized' swings (**8**). Fences have also been installed to improve the security around the sculptures (**9**).

Nek Chand has continued to fight battles with the authorities to preserve the Garden from the threats of demolition and to secure resources for its expansion. However, he has remained reticent to dicuss its evolution or the influences and inspirations behind his unique collection and its architectural and landscape setting. The following section attempts to arrive at an understanding of his creation by placing the work in its relevant political and cultural context.

————

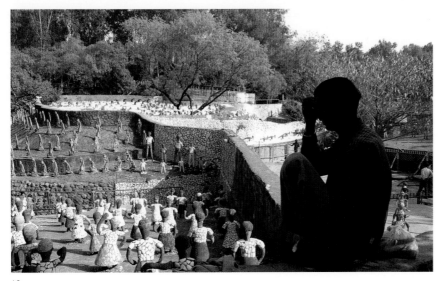

10

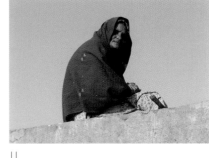

11

Collection, the ruin and the theatre: the making of another Chandigarh

We have given the exhibition the above title as we believe this best represents the nature of the Rock Garden and its relationship with Chandigarh, into which it was eventually incorporated and with which it has remained intimately related – often in opposition but also in collaboration. As the early history of the Garden has shown us, from its surreptitious beginnings as a collection of rocks it has evolved as a pariah, through its physical isolation, as well as, resulting from its contravention of the laws set out in Le Corbusier's edict[15] and the zoning principles of the city. This early development within the designated greenbelt zone is characterised by an 'illegal' exploitation of unused land – effectively abandoned scrubland – on the periphery of the city, coupled with the innocent enthusiasm of the pioneer explorer/maker.

Paradoxically, Nek Chand was able to exploit this territorial void – an uncharted wilderness nestling under the shadows of the famous buildings of Sector-1 – being an 'insider', given his access to the Public Works Department stores on the site as an employee of its Roads Section. From Chand's point of view the space was ideal, he could work undisturbed and with little chance of being caught, his material located close by and in regular supply.

Within such a context Nek Chand began constructing his world of – what was essentially, at that stage – a collection of rocks, zealously guarded from their invisible positions by a small group of devoted subordinates of Saabji (respected senior), reminiscent of the mythic Rama's kingdom in exile in the epic Ramayana, a feature of protection that has remained unchanged over the years (**10**). Thus emerging stealthily out of a context entirely configured and produced by Modernism and

Independence, this small world – an ever extending collection of bizarre rocks, in an unselfconscious way, began to question and overturn the very conceptual tool employed in the making of Chandigarh – the Modulor and its harmonious proportions. Nature had to be called in to question Chandigarh's *raison d'être*. Thus within a few years of Chandigarh's foundation, which the first Prime Minister of India Jawaharlal Nehru had so grandly proclaimed would remain 'unfettered by traditions' (Evenson 1966), the city had encountered a new – another – Chandigarh in its own back garden. Though unfettered it was by tradition, the questioning of the nature/culture divide and the legible order – held sacrosanct in Modernism, paved the way for the curious groupings of bizarrely proportioned – even grotesque – objects redolent of the primitive and the ancient cosmogonic myths.

19

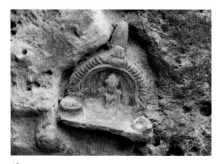

12

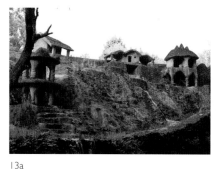

13a

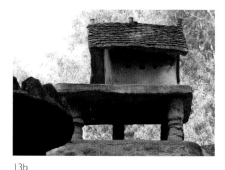

13b

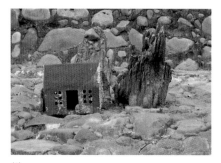

14

While Nehru's declaration would suggest and as Chandigarh's makers would make us believe, a city rising from *tabula rasa*, the reality as we have observed was different, as twenty-four villages and its nine thousand residents were forced to relocate from their fertile agricultural land (**11**). The process is reminiscent of another city-making nearly a millennium earlier during the foundation of the first Islamic state in India, in Delhi. In their zeal to remain fettered to the commandment that Modernism should dissociate itself from tradition, the city even before its birth had severed its ties with its progenitor, the village of Chandigarh with its temple of goddess Chandi – which even today lies on the outskirts of the sprawling state capital – uncelebrated. Curiously therefore, while the 'otherness' appears to have been built into the very making of the city, the auspicious omniscience of the goddess of power (*shakti*), as Prakash poignantly speculates, will have coloured the choice of

the site, at least in the minds of the many Hindu decision makers (Prakash 2002: 8).

Allusions to the cultural history of an ancient and complex civilisation was not excluded either, as the destruction of these villages provided Nek Chand with another source of material in his creative endeavour. In the initial sculptures, landscape and architecture we therefore see the pleasantly surprising incorporation of shards of traditional pottery and the occasional sacred icon (**12**), transforming the primordial and universal to the local and the historical, and breathing a narrative hint of the catastrophic transformation in the lives of the erstwhile residents. Over time, continuing with the tradition of miniaturised microcosm he had instilled in his early ensemble, this interest in the destroyed past of Chandigarh expanded into the making of an entire series of desolate hutments (**13 a & b**) (perhaps tried out first as a tin-canister maquette, **14**),

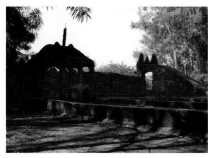

15

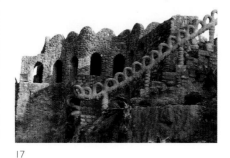

17

inhabiting a fabricated mountainous setting which extended on to the Corbusieresque rooftop of his guesthouse (**15**). The folly, the architecture and the landscape are all interconnected and impossible to dissociate. While the unfinished, the ruin and the obsolete had also preoccupied Corbusier during his Indian endeavour, this was entirely internalised within the architecture and in the fabrication of its immediate context (Temple and Bandyopadhyay in press), and was never allowed to invade the conception and plan of Chandigarh. In the later work of Nek Chand, as we meander through the monumental gorges and caverns, we observe the growing obsession with these ideas and its appearances writ large on almost urban proportions (**16 & 17**). Here, obsolescence and redundancy is all pervasive. Stepping outside of the immediate context of a ruptured local history, the architecture is decidedly sedate, perhaps losing itself in the lacunae of Romanticism that coloured the perceptions

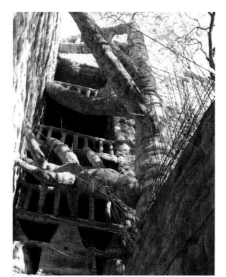

16

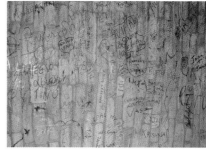

18

19a

19b

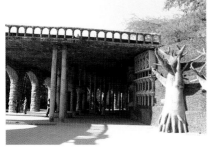

20

of the nineteenth century colonial painters such as the Daniells.

The architecture and landscape in Phase-3 is unequivocally theatrical, perhaps more redolent of settings of Bollywood films of the time, basking in its growing popularity as a tourist destination, but also reeling under it. This is attested by the many inscriptions of love testimonials left behind by visitors on the stone and ceramic walls of the Garden (**18**). It is this augmented status amongst the Indian populace, far outstripping that of its host city, that allows the Garden the confidence to usurp the city itself, ingesting its iconic buildings and urban features into representations in bas relief (**19 a & b**). Sculptural traditions of rock-cut temples fuse with Mughal architecture and traditions of wall decoration, producing pavilions through which its creator is now able to look beyond the geographical confines of the country to similar sustained and passionate creations elsewhere, possibly

towards Gaudi in Barcelona (**20**). The theatricality is sustained in the conflict between the nature and implied strength of these large-scale concrete architectural gestures (pavilions) and the method of using the material itself. The process of application of entire bags of cement stitched together to produce a bulbous and more 'organic' appearance – first tried out in the large landscape initiatives in Phase-3 – are suggestive of rag doll making prevalent in Rajasthan and introduced into the Garden by Nek Chand (**21 & 22**).

Elements of a more vital theatre were present in his earlier work as he took the first tentative steps in creating landscapes employing the thousands of rocks he had collected from the river beds. Although not fully articulated, the rock features embedded in the walls are suggestive of grand narratives consisting of numerous characters and narrative strands (**23 a & b**). These recall *Gangavatarana*,

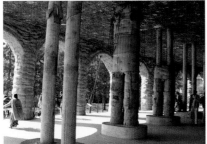

21

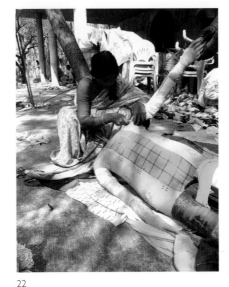

22

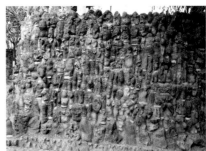

23a

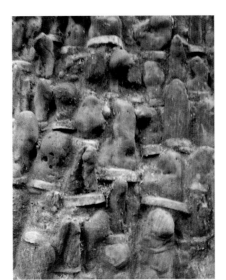

23b

the celebrated rock carving of a grand
narrative on the hill face near Chennai
in Tamilnadu, depicting the penance of
Arjuna in *Mahabharata* as retold by an early
Tamil poet, weaving in myriad strands of
celestial and terrestrial narratives. Theatre
is enmeshed with a labyrinthical mystery
and the unexpected joy of discovery, a
constant theme in the middle phase of
Nek Chand's Rock Garden. One could
even argue that theatricality was integral
to the Garden from its clandestine
formative days as a collection of rocks,
for latent in the ambiguity of the pieces
was a certain multiplicity of meaning that
defied and made problematic conventional
categories of classification, an issue we
intend to discuss further in this chapter.
The theatre appears to make metaphoric
– but often more direct – allusions to, and
comment on, the wider theatre surrounding
Chandigarh, its conception and the fate of
a particular polemical brand of Modernism
propounded by Le Corbusier, within the fast

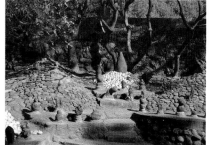

24a

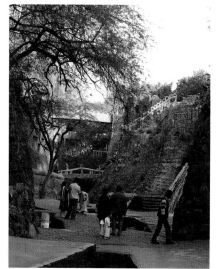

24b

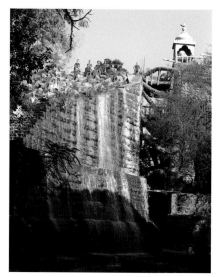

24c

changing urban reality in India and its post-independence cultural leanings.

Of particular interest is the understanding we gain of the fledgling battle Nek Chand had had to wage with the Chandigarh authorities, which at times reached farcical proportions. The early phase with its monochromatic, apparently valueless collection of rocks – much of which was evidently portable – and the absence of a grounded landscape and architectural setting, supports the secret and threatened existence Nek Chand's Rock Garden had to endure. The gradual increase in the size of collected rocks – an indication of Nek Chand's more serious investment in the project, the experimentation with and production of sculptures, and a more formed landscape of the middle phase, on the other hand, speak of its journey through rocky, and at times unsure, but gradual path towards a full legal existence. Finally, Phase-3 is indicative of a confidence underpinned

by institutional support resulting from a realisation that Chandigarh's survival in the popular mind was integrally intertwined with the future and longevity of the Garden. While the Garden has incorporated aspects of Chandigarh's iconic architecture, the city has resigned itself to the ever-increasing embrace of the Garden (**24 a, b & c**). Without overtly stating a political agenda, Nek Chand's garden has managed to create another Chandigarh. This 'other' Chandigarh emerges, not so much in total 'opposition' to the host through an utter negation of the dominant city themes, but employing in Saidian parlance, a 'contrapuntal' relationship with the city, that is, by establishing precise 'counterpoints' (Said 1993)[16], which Nek Chand cleverly constructs – perhaps unconsciously – by inverting or subverting the rules underlying the various city themes.

Nek Chand's rock collection: 'passion bordering the chaos of memories'

With this we now turn to Nek Chand's collection of rocks and sculptural production. Very early on in Chandigarh, he had developed a passion for collecting unusually shaped rocks formed in the Himalayas, which he collected with passion and imagination. He would gather the rocks from the seasonal Sukhna Cho, Patiala Rao and Ghaggar rivers that flow through the surrounding Shivalik Hills. On an almost daily basis he would venture off into the hills on his bicycle in search of specific rocks. The riverbeds, literally made up of thousands of rocks, afforded Nek Chand the opportunity to overturn, rearrange and pick up rocks from the riverbed. He would select certain rocks according to his preference and remove them before taking them back to the edge of Chandigarh. His selection options at this

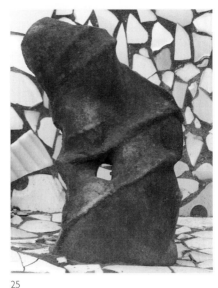

25

point were heavily constrained by what could be carried on the back of a bicycle and the number of trips one could possibly make in a day; picking also depended on the season of the year and importantly, on the then clandestine and threatened nature of the repository site. Rocks were selected depending on their appearance, texture, erosion, difference from previously selected rocks and whether they resembled something else, i.e., a face, person or an animal. Walter Benjamin succinctly sums up the complexity of issues traversing the mind of a passionate collector,

> Every passion borders on the chaotic, but the collector's passion borders on the chaos of memories. More than that: the chance, the fate that suffuse the past before my eyes are conspicuously present in the accustomed confusion of [the collection] . . . Naturally [the collector's] existence is tied

to many other things as well: to a mysterious relationship to ownership, to a relationship to objects that does not emphasise their functional, utilitarian value – that is, their usefulness – but studies and loves them as the scene, the stage, of their fate. (Benjamin 1999 reprint: 65)

For Nek Chand the problem surely was not finding the rocks to collect – since supply of such material was endless, but the method of its retrieval and most importantly, the storage of his collection. In the early collection one can discern two categories of rocks; first, the rocks found on the riverbed – mostly basalt – eroded and shaped by its environment into intricate forms, clearly suggestive of humanoid or bestial formal qualities (**25**). Secondly, the heavier, smoother, more rounded and less eroded monoliths, often with deep penetrative incisions or apertures,

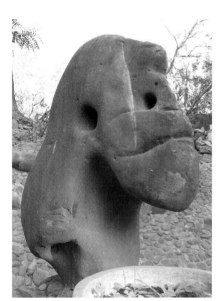

26

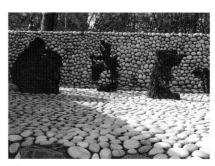

27

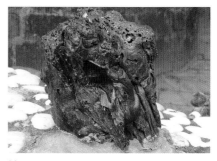

28

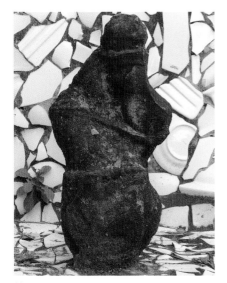

29

suggestive of primitive amorphous life form (**26**), and thirdly, a small number of magma-like rocks evidently shaped by volcanic activity. In addition, at some stage Nek Chand collected discarded metal slag peculiarly shaped as the molten metal made contact with the ground, perhaps a by-product of the city's development (**27**).

This early material has had a poor press within the popular discussion of Nek Chand's creative endeavour, which has mainly concerned itself with the later, decidedly more colourful ceramic-clad concrete sculptures. The study of the early collection, however, provides us an excellent understanding of the varied themes at the core of Nek Chand's interests as a collector and the resultant assemblages. Since storage in all cases was closely related to some form of display, it had, from the outset, important classificatory and interpretive implications. Given that Nek Chand found these rocks immediately and somewhat

unambiguously suggestive of *something* amidst thousand such forms, the need to bring out that especial quality was integral to the act of collection and its storage. To bring out the humanoid and bestial qualities necessitated arranging the rocks on plinths, which in many cases, has had an important effect on our understanding of how the piece was formed or came into being. If we take the volcanic rocks, for instance, these appear to gush forth from the bases, its spewing lava momentarily frozen capturing the act, suggesting a stronger bond between the objects and its bases (**28**).

From the twilight of memory: the mythic, the erotic and the primitive

The humanoid figures, draped as it were in finery, posture elegantly and dynamically to recall some of the early Indian sculptures of dancers and celestial beings from the rock-cut caves of central India, especially

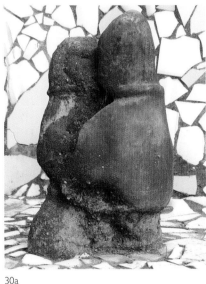

30a

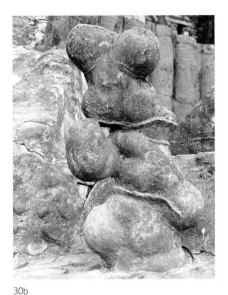

30b

from Ellora, and the stupa gates of Sanchi and Bharhut (**29**). The rough weather-hewn texture of the rocks give these a timeless archaic quality, helping us to make this particular connection, yet these are modern enough in their abstraction. Often presented as torsos, tempting us to complete their forms in our mind, their collective presence allude to a gallery of minstrels in gaiety. Some rock forms suggest conjoined bodies – perhaps engaged in romantic courtship or perhaps more – redolent of the erotic sculptures of the temples of Khajuraho and Konarak, highlighting a significant erotic content in the collection (**30 a & b**). However, the erotic is not the prerogative of these more complex forms, since many of the so-called single forms are suggestive of torsos of voluptuous female bodies (**31**). There is an abundance of phallus-like objects in the collection, projecting through the ground, underscoring a possible reading of the latter as the eternal female (**32**). That short pillars

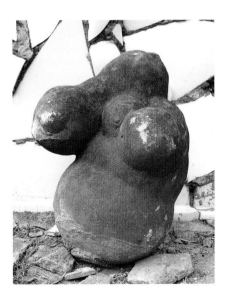

31

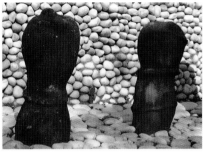

32

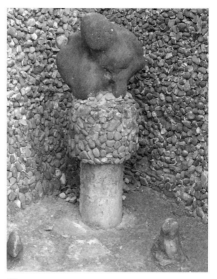

33

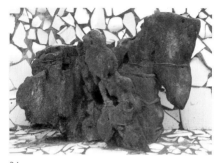

34

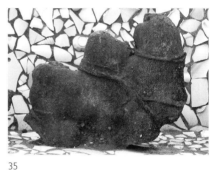

35

– be these natural or man-made – were given a phallic and procreative significance is evident from the use of at least one of these as pedestal for an animal pair in possible coital act (**33**).

In contrast, all animal forms – except the horses, which, not withstanding its tremendous dynamism, appear to be struggling to shake off the shackles of ossification (**34**) – are suggestive of heaviness, strength and stasis. Often appearing in isolation, many of these are indeed formed resembling the bull, bison or indeed beasts from the Jurassic age, the latter more true of the metal slag sculptures (**35**). The metal pieces, arranged in groups, bring to mind a herd of grazing primitive creatures, which have stopped and turned its heads to listen intently to the mumbling astonishment in the visitors' voices (**36**). While the creatures represented through the stones of smoother appearance are also primitive in form with characteristic slowness, these appear to be amphibious beings or even creatures of the watery abyss (**37**). The deep holes present in these rocks appear as apertures to its inner depths, as if the soul will issue forth bringing with it the nature of the being itself. While often suggestive of a dominant form, many of Nek Chand's rocks offer the opportunity of multiple reading indicating an inherent ambiguity in the collected pieces, as is the case with the diminutive figure expected to be read as the decapitated body of a bull or a rhinoceros. Turned through ninety degrees it could be read as a muscular male torso with his navel clearly visible or even a male face, indicating the close and interchangeable relationship that exists between the beast and the humanoid (**38 a & b**). This close relationship between the two life forms and the conjoined primitivity is carried through into some of the early sculptures Nek Chand produced (**39**). Unexpectedly, thus, we stumble across strange parallels between Le Corbusier's

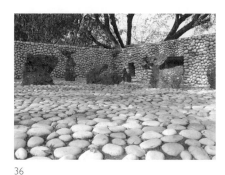

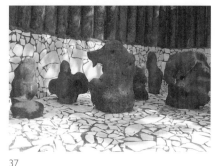

36

37

fascination with the primitive, the primordial and the grotesque and Nek Chand's collection of rocks. Perhaps certain aspects of Corbusian Modernism, also manifested in his interest in the cosmogonic and the mythic, are not so distanced, after all (**40**).

Fettered by archaeology

Chand makes use of discarded objects and, through a change of context and assemblage, brings those back from the brink of their useful existence into his resurrected collection of Rock Garden artefacts, which take on different meanings as a result of this transformation. His sculptures are the product of the ruins and the ruined or discarded objects that undergo subtle but profound transformations into artefacts retain evidence of its previous incarnation. When the twenty-four villages that stood on the site were demolished to make way for the city, the remains of the homes and

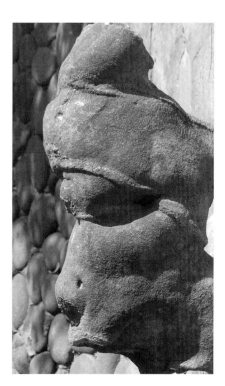

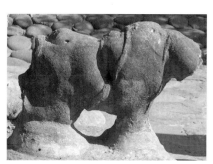

38 a (top) b (left)

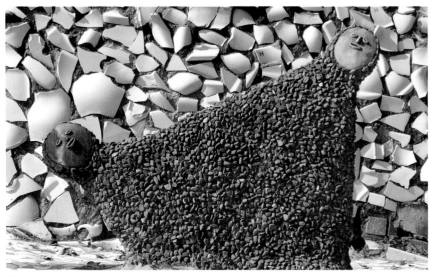

39

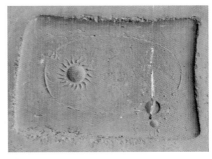

40

belongings were discarded. It was this debris that Chand quarried and obtained the initial pieces for his venture, salvaging in the process many of the ruined objects and structures that occupied the site before Chandigarh. This process has continued, recycling the debris from the contemporary city, with Chand acting as a commentator, narrator and translator of the city and its inhabitants, whilst simultaneously retelling historical folklore into physical daydreams. Nehru wanted Chandigarh to be the new Indian City unfettered by the past – ahistoric to some extent, and definitely un-archaeological. Yet Chand's Chandigarh depends on the past – on the physical debris that resulted from, what can be termed a catastrophic erasure – and alludes to mythological and popular themes re-contextualised in historical debris. The mythological content underpins the resurrection and elevates the otherwise unremarkable fragments.

Chand judges the object on its aesthetic and material properties, generating new readings based on its revised context and form. Chand makes the entire sculpture from one type of object, intensifying its qualities and making direct connections with the occupants of the city through this repetition of the familiar and the mundane, thereby trapping the lifestyles, and by extension, the peoples within the sculptures. Curiously enough, concrete is employed to bind the fragments together, which is also the material preferred by Corbusier in the Capitol Complex. However, there is the difference: the concrete used here is the connector (the binder) and not the principal component, relegating it to a secondary status. An important element of Chand's work is that the original function and 'history' of the object is never dismissed or lost; the small inexpensive fashion accessory becomes the portrayal of something much more significant (**41**).

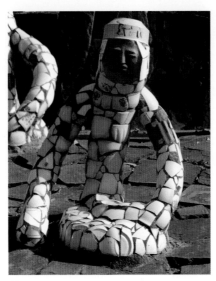

41

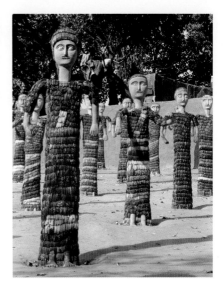

42

A group of the sculptures is clad in thousands of coloured glass and plastic bangles that have been salvaged (**42**). The bangles relate to the huge multitude of the girls who once lived, and are possibly still living, in and around Chandigarh. Broken bangles retained carry misfortune prompting owners to discard them forthright. To Chand those are the final and most important materials in completing the sculptures. The object is stripped of its function and from its conventional reality as a product; its original function as bangle is replaced with something else, as a drape or colourful clothing on an anthropomorphic sculpture. The tragedy attached to most of the discarded materials is in this way reversed as Chand transforms the objects whilst retaining the aesthetic qualities. The

bangle that was once worn on a girl's arm is now part of a sculpture of a girl. The bangle as symbolic of puberty and femininity has been writ large: the bangle becomes the girl! Moreover, they confront the audience – an audience, primarily Indian, hailing from the strictures of the male-dominated society. They face the audience in their multitude, as seldom these sculptures are on their own. They ask questions.

————

References

Ahmed, S. K. (October 20 1989). 'Nek Chand wins battle against lawyers'. *Indian Express*: 3.

Arac, Jonathan. (1998). 'Criticism between Opposition and Counterpoint', *Boundary 2*: 25(2): 55-69.

Aulakh, M. S. (1986). The Rock Garden: *A panorama of the life-work of Padam Shri Nek Chand*. Ludhiana: Tagore Publishers.

Benjamin, W. (1999 reprint). *Illuminations*. London: Pimlico.

Bhardwaj, A. (November 4 1991). 'Nek Chand allowed to expand garden'. *The Times of India*: pagination unknown.

Bhatti, S. S. (1982). *Rock Garden in Chandigarh: a critical evaluation of the work of Nek Chand*. Queensland: The University of Queensland.

Bhatti, S. S. (1989). 'The Rock Garden of Chandigarh'. *Raw Vision Magazine* 1: 22-31.

Chand, N. (February 16 1993). 'Facts about Rock Garden'. *The Tribune* (Chandigarh): 8.

Chandigarh-Heartbeat (Nov 19 1993). 'From waste to art and back to waste'. *The Tribune* (Chandigarh): no pagination.

Chandigarh-Newsline (February 16 1994). 'Third phase of Rock Garden stalled'. *Chandigarh Newsline*. no pagination.

Chandigarh-Newsline (July 20 1996). 'Art pieces damaged in Rock Garden'. *Chandigarh Newsline*: 2.

CITCO. Rock Garden. Chandigarh, Chandigarh Industrial & Tourism Development Corp Ltd.: no pagination.

Crosbie, M. J. (1986). 'Silent Sentinels' from India'. *The AIA Journal* 75: 31.

Evenson, N. (1966). *Chandigarh*. Berkeley: University of California Press.

Express-news-service (June 14 1992). 'Red tape ties up Rock Garden work'. *Indian Express*: no pagination.

Express-news-service (October 7 1992). 'Work at Garden stalled'. *Indian Express*: no pagination.

Krishan, G. (1999). *Inner Spaces - Outer Spaces of a planned city*. Chandigarh: Chandigarh Perspectives.

Maizels, J. (2003). 'Creator of a Magical World'. *Vernacular Visionaries, International Outsider Art*. A. Carlano (ed.), Yale University Press.

Menon, R. A. (August 3 1997). 'Crumbling Eden'. *The Express Magazine*: 1 & 4.

Parihar, R. (April 22 1992). 'Not on waste foundation'. *Indian Express*: no pagination.

Parihar, R. (February 9 1993). 'What ever happened to Rock Garden-III'. *Indian Express*: no pagination.

Prakash, Vikramaditya. (2002). *Chandigarh's Le Corbusier: The Struggle for Modernity in Postcolonial India*. Seattle: Washington University Press.

Puri, N. K. (November 18 1996). 'A dream vandalised'. *The Hindu*: III.

Said, Edward. (1993). *Culture and Imperialism*. London: Chatto & Windus.

Saxena, M. (November 18 1995). 'Mela Culture at Rock Garden'. *The Tribune* (Chandigarh): 19.

Sharma, M. N. (2001). 'Nek Chand: an early encounter'. *Raw Vision* 35: 28.

Singh, N. (September 12 1996). 'Don't neglect Rock Garden'. *The Tribune* (Chandigarh): no pagination.

Temple, N. & Bandyopadhyay, S. In press. 'Contemplating the Unfinished: Architectural Drawing and the Fabricated Ruin'. In Frascari, M. *et al* (eds.) *From Drawings to Buildings*. London: Routledge.

The-Tribune (April 24 1990). 'Nek Chand V's VIP Road'. *The Tribune* (Chandigarh): 6.

The-Tribune (March 29 1992). 'Spurious Cement stalls work at Rock Garden'. *The Tribune* (Chandigarh): 12.

The-Tribune-Bureau (April 21 1990). 'Part of Rock Garden to be demolished'. *The Tribune* (Chandigarh): no pagination.

Tribune-news-service (September 2 1996). '26-minute episode on Rock Garden'. *The Tribune* (Chandigarh): no pagination.

Tribune-news-service (September 24 1993). 'Third Phase of Rock Garden opened'. *The Tribune* (Chandigarh): no pagination.

Notes

1. This information was checked with Nek Chand during fieldwork between 2004 and 2006. See also Bhatti, S. S. (1982). Rock Garden in Chandigarh: a critical evaluation of the work of Nek Chand. Queensland, The University of Queensland. Preface, p. xx. This is also confirmed by John Maizels in an interview he held with Nek Chand. See, Maizels, J. (2003). Creator of a Magical World. *Vernacular Visionaries, International Outsider Art*. A. Carlano (ed.), Yale University Press. p. 67.

2. This plan is based on information gathered from Chandigarh city museum, the Chandigarh School of Architecture library and Krishan's study. Krishan, G. (1999). Inner Spaces - Outer Spaces of a planned city. Chandigarh: Chandigarh Perspectives.

3. Nek Chand told Jackson that he would work at the garden for up to four hours per day, from when he finished work as a road inspector. He would also work at the garden over weekends and holidays.

4. The mention of 'being free from the interference of architects and town planners', would suggest that there had been some interference. Could Randhawa have been referring to MN Sharma?

5. This interview with Jackson in March 2005 was not recorded; however, extensive notes were taken and recorded in the site workbook. To add to the problem, Randhawa is now deceased. No official papers, if they exist at all, have been accessible during the last three years of repeated attempts to obtain them.

6. In our correspondence with Chaturvedi he confirmed that he visited the garden many times during the late 1970's in his official role as Chief Commissioner 1976-1978 (personal correspondence with Jackson, 9th August 2006). He wrote that he was able to give Nek Chand the support and protection he needed to establish the garden. TN Chaturvedi was moved to the Ministry of Home Affairs in 1981 where he was able to assist Nek Chand and ensure consistent financial support. He also orchestrated Nek Chand's visit to Washington DC, to install the sculptures in the city's Children's Museum, where he delivered an opening address.

7. Nek Chand describes the incremental construction of the garden according to three phases. Phase-1 contains the early rock collection, Phase-2 contains the sculptures and in Phase-3 the larger landscape and architectural works are found. Describing the garden according to phases of production relates back to Nek Chand's time in the construction industry and also to the method of constructing Chandigarh. We have adopted this temporal categorisation in our subsequent discussion.

8. The perimeter wall was extended in 1983-1984 to permit the expansion into Phase-3.
9. Personal correspondence between Jackson and TN Chaturvedi, 9th August 2006, *op. cit.*
10. The garden at the Children's Museum has recently been dismantled, with the sculptures now rehoused at the American Folk Art Museum, New York.
11. There is an element of irony in this claim, as the Botanical Garden was not part of the Master Plan either.
12. Between 1989-1991, Nek Chand argued that the Rock Garden made between Rs 3 to 4 Lakh per annum, (approximately £3740-5000), with costs of between Rs 19-34 Lakh in the same period, and that the latter, after the completion of the phase, would be considerably reduced. The expenditure by the Administration on the other parks was 80% more. All figures supplied by Nek Chand. Chand, N. (February 16 1993).

Facts about Rock Garden. *The Tribune* (Chandigarh):8.
13. When Nek Chand was away in the US, of the fourteen permanent members of staff, only five were retained in the Rock Garden, sixteen daily wage staff were sent to work on other projects leaving only fourteen on site; see Puri, N. K. (November 18 1996). A dream vandalised. *The Hindu*: III.
14. See http://www.nekchand.com for more information.
15. The Edict of Chandigarh is on display in the leisure valley on a plaque and its object is '. . . to enlighten the present and future citizens of Chandigarh about the basic concepts of planning of the city so that they become its guardians and save it from the whims of individuals'. It was a simplified edition of Le Corbusier's document entitled, 'For the Establishment Statute of the Land', which contained three sections

and was presented to the High Level Committee.
16. For a discussion on 'contrapuntal' and 'oppositional' criticism, see, Arac, Jonathan. 1998. 'Criticism Between Opposition and Counterpoint', *Boundary 2*: 25(2): 55-69.

Illustrations

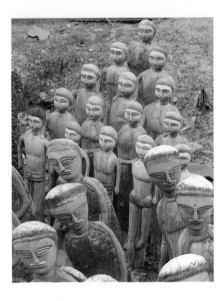

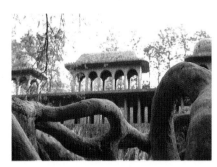

22. Rag dolls, a craft tradition of possible Rajasthani origin, introduced into the Rock Garden by Nek Chand

23. Walls within the Rock Garden constructed of stones collected from the riverbeds, general view (a) and detail (b).

24. Landscape in the early (a), middle (b) and late (c) phases.

25. Eroded and shaped by the environment: humanoid sculptures.

26. Primitive amorphous beings.

27. Metal scrap as sculpture.

28. A frozen moment in volcanic eruption.

29. Torso of a dancing minstrel.

30. The erotic in the early found rocks.

31. Body in space: a female torso.

32. Phallic forms penetrating through the ground.

33. A small creature on a pedestal with a bulbous head.

34. Struggling to shake off the shackles of ossification.

35. The sacred bull, a common feature of Indian markets and towns.

36. Herd of primitive creatures.

37. Creatures of the watery abyss.

38. The rich ambiguity of the found rocks is fascinating.

39. Conjoined creatures in Nek Chand's early sculptures.

40. Le Corbusier, Assembly Building, Chandigarh: detail from a pylon at the entrance.

41. Nek Chand's translation of everyday objects.

42. The multitude of 'bangle' sculptures.

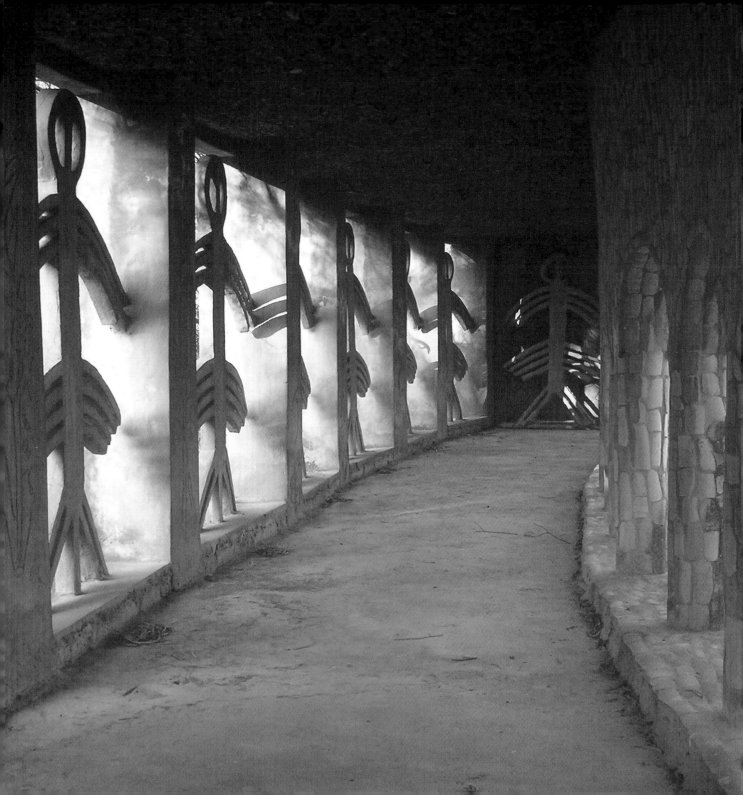

The backdrop

The following pictorial essay illustrates the general setting and arrangement of the Rock Garden, within the wider context of the city and especially in relation to its immediate surroundings and topography. The Capitol Complex that Le Corbusier designed is located to the west of the Garden, while the undulating topography surrounding the latter provides ample clues regarding the terrain prior to Nek Chand's significant modifications.

In Chandigarh the adoption of Modernism was essential in creating an immediate physical representation of the vision of independence expounded by India's first Prime Minister, Jawaharlal Nehru, which strove for an aesthetic that was truly of its time and dreamt of a future free from the shackles of the past. Nehru's enthusiastic participation and active role in the decision making process showed how importantly India viewed the need to establish an appropriate visual manifestation of the new

order. As well as developing the Master Plan and the Capitol Complex, Le Corbusier ensured that extensive visual controls were in place to nurture a homogenous aesthetic and a visual standardisation, an obsession that extended to include virtually all components of architecture and the man-made landscape.

However, the design of the Capitol Complex with its constituent buildings, the Secretariat, the Assembly and the High Court, hold a richness characteristic of the late work of Le Corbusier. Attempting to overcome entropy, Le Corbusier's creativity lay in the equilibrium he sought between the models of the past and the monuments of the future, by exploring means of establishing reciprocity and coexistence between the 'unfinished' and the 'ruined'. Such approaches have been emulated by later Indian architects such as Balkrishna Doshi and Charles Correa and the more recent generations of Indian architects. The

opportunity of the unfinished manifests itself interestingly in Chandigarh, evidenced most explicitly within the grounds of the Capitol Complex. Reconciliation between the remnants of civilization and nature allowed for the ambiguity of the unfinished to unfold to provide an opportunity for the intrusion of Nek Chand's Rock Garden, a project – more popular than Chandigarh itself – one that contradicts every aspect of the edict of Chandigarh.

A

B

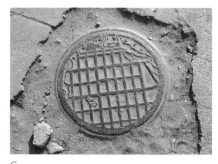

C

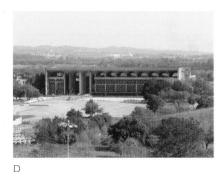

D

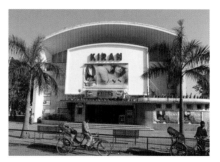

E

A. Within the Assembly Building there are various relief casts in the concrete walls, especially on the pylons supporting the entrance portico. These depict cosmogonic and mythic concepts holding significant meaning to Le Corbusier. The one shown here depicts the lunar and earth cycles about the sun.

B. Sector-17, the main commercial and shopping district of the city. The architectural controls have created buildings of uniform façades and scale within the city. However, shop advertisements have increasingly disrupted this uniformity. Trees have been planted to give some shade to the shoppers and to reduce the glare reflected back from the concrete paving.

C. The architectural controls in the city even extend to the manhole covers. Here, the plan of Chandigarh is cast into the cover.

D. The High Court Building, Sector-1. The vaulted roof is designed to shelter the main building underneath, and metaphorically act as the protecting umbrella of justice.

E. The Kiran Cinema, Sector-22 designed by Edwin Maxwell Fry, one of the two English architects to assist Le Corbusier and Jeannerret (the other being Jane Drew).

The Assembly Building. A complex series of forms make up the structure, which following the decision not to build the Governor's Palace, has become the 'centre piece' of Sector-1. The *brise-soleil* ensures that direct sunlight does not penetrate into the building. On the northeast façade an elaborate portico-cum-guttering system alludes to classical proscenium tradition, sheltering the ceremonial entrance. The truncated-hyperboloid roof form expresses the assembly chamber beneath, whilst the eccentric pyramid marks the location of the council chamber.

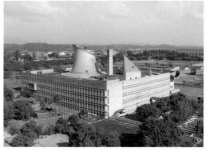

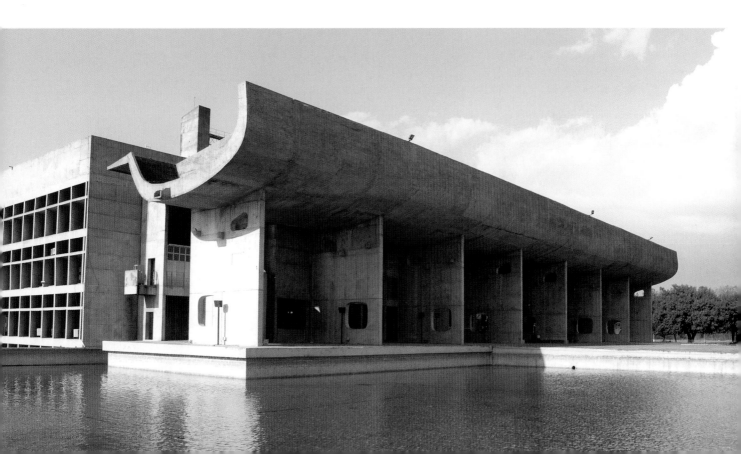

The collection, the ruin and the theatre

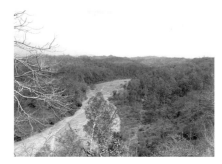

Right: The topography adjacent to Phase-3 and approximately how the site would have been prior to the establishment of the Rock Garden.

Above: The Ghaggar River bed in the dry season. This is from where Nek Chand gathered most of the rocks that are now in the garden. Each new monsoon brings fresh rocks down from the mountains.

Opposite: Plan of Chandigarh with the pre-existing village locations superimposed.

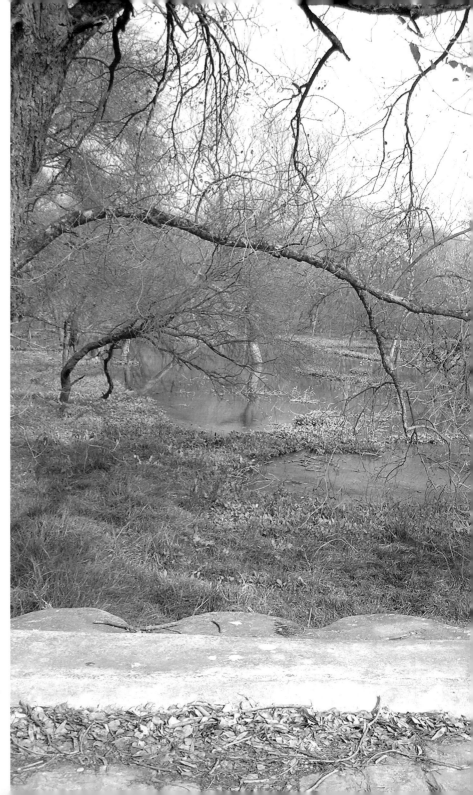

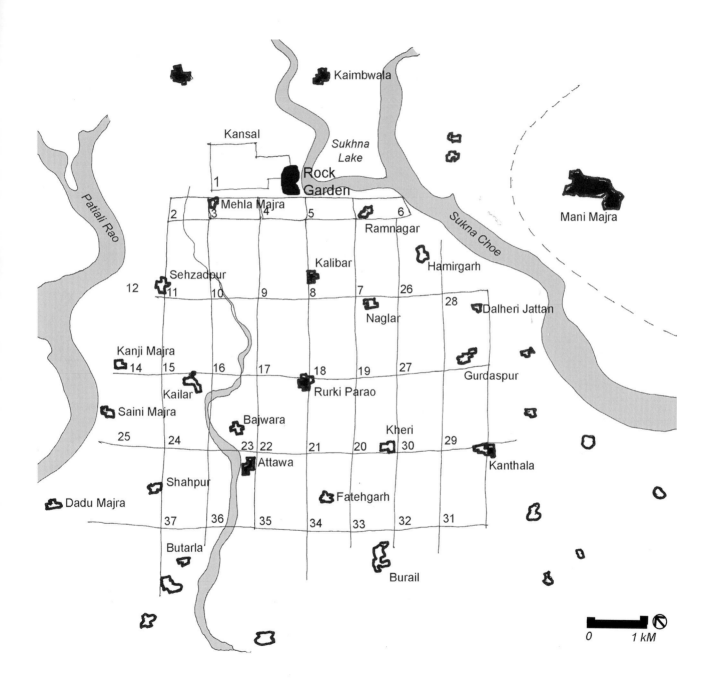

Kaimbwala

Kansal

Sukhna Lake

Rock Garden

Patiali Rao

Mani Majra

1

2 3 Mehla Majra 4 5 6
 Ramnagar

Sukhna Choe

Kalibar

Hamirgarh

Sehzadpur

12 11 10 9 8 7 26
 28
 Naglar Dalheri Jattan

Kanji Majra

14 15 16 17 18 19 27
 Rurki Parao Gurdaspur

Kailar

Saini Majra

25 24 23 22 21 20 30 29
 Attawa Kheri Kanthala

Bajwara

Shahpur

Fatehgarh

Dadu Majra

37 36 35 34 33 32 31

Butarla

Burail

0 1 kM

43

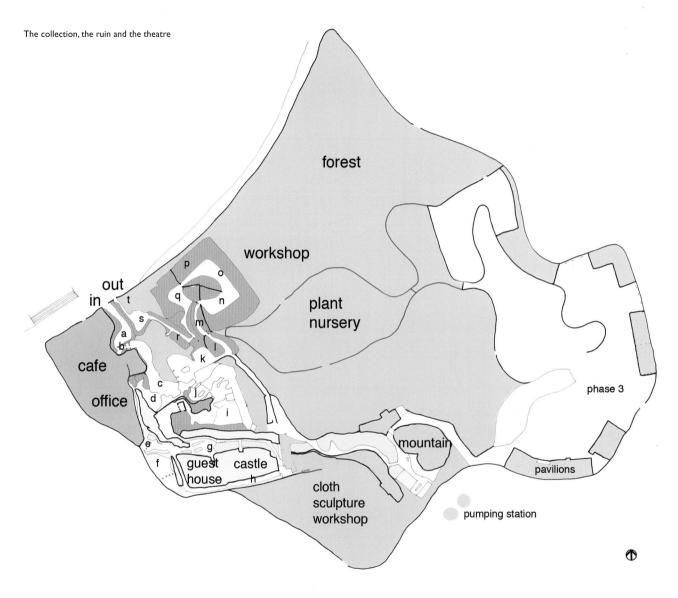

forest

workshop

plant
nursery

out
in

cafe

office

mountain

phase 3

pavilions

guest
house

castle

cloth
sculpture
workshop

pumping station

Above: The plan as it is today was fixed in 1983. Prior to that point it was extended one chamber at a time to accommodate new additions to the garden. Within the café is Nek Chand's office. The vast majority of the garden is inaccessible to the public at present (here shown in light green), most of which remains a forest or in use as workshops. The plan fails to properly convey the spatial qualities of the garden. This is partially because it is built out of the topography and also because of Nek Chand's working method. He does not 'plan' the space or organise it, but considers it from an experiential perspective. The result puts more emphasis on the façades and journey through the space.

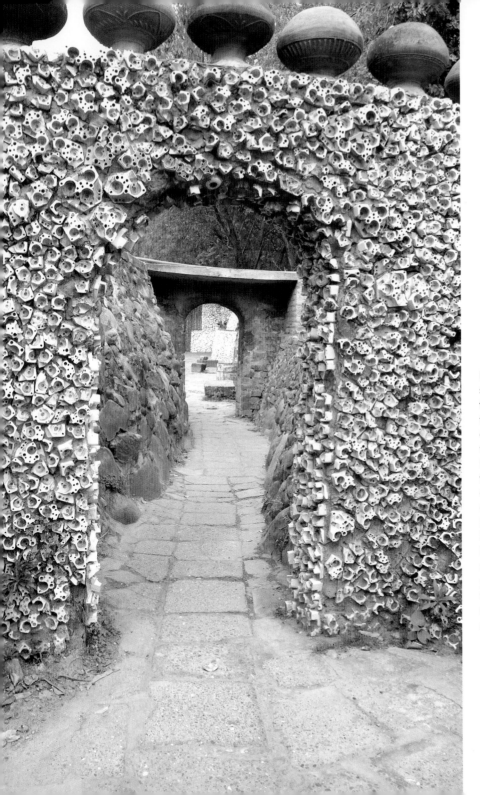

Left: The Rock Garden is divided into several chambers, each one with its own features added over an extended period of time. The chambers are divided by a series of walls with access to the next chamber through a low archway. The archways were initially made as they eliminated the need for a lintel and could be formed using found objects such as oil drums. Nek Chand continued to use the archways beyond the initial functional necessity and they have become a familiar feature throughout the Rock Garden. The dividing walls are also used by Nek Chand's staff as high-level pathways through the site. These continue the tradition of surveillance established very early on to keep out intruders. Today, the staff keep a watch over the tourists.

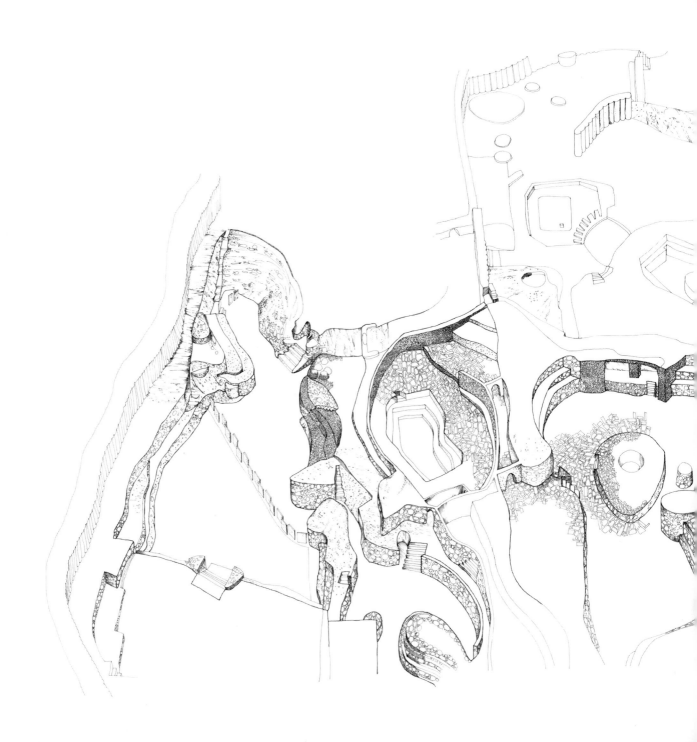

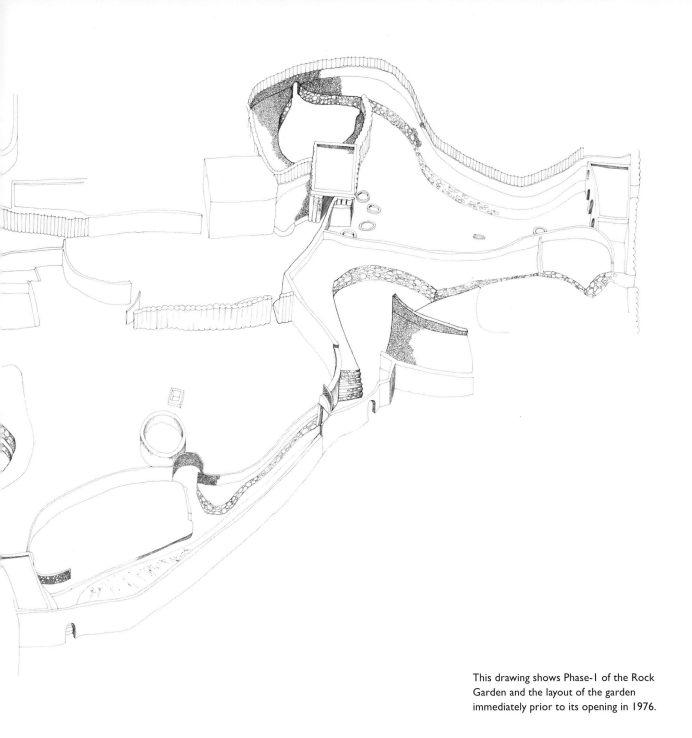

This drawing shows Phase-1 of the Rock
Garden and the layout of the garden
immediately prior to its opening in 1976.

Right: Nek Chand photographed in the Rock Garden in February 2004.

Opposite: Nek Chand's office is like a small museum dedicated to Rock Garden memorabilia. It is located in the cafeteria section of the Rock Garden, built just after the initial opening in 1976. It contains his collection of press cuttings, exhibition boards and large format photographs. The office has a barrel-vaulted roof with inset pebbles and the entire building is a bridge structure spanning a dip in the terrain.

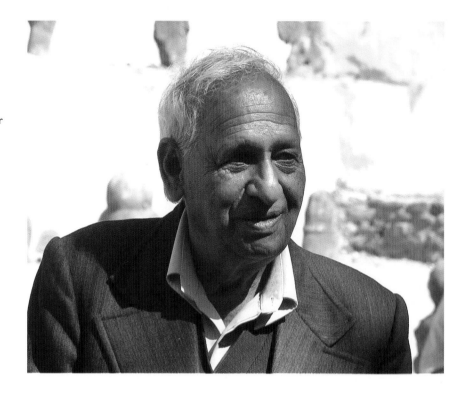

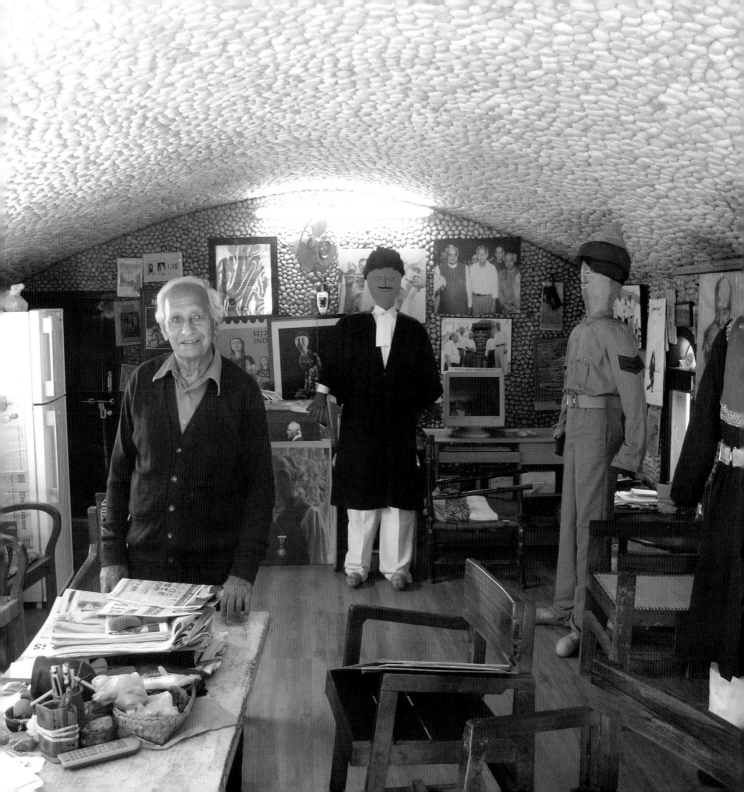

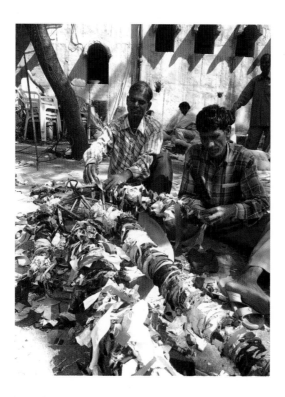

Nek Chand received informal help from friends and road builders and employees of the PWD whilst the garden was still clandestine. However, since its discovery a more formal workforce has been at his disposal, many of whom hail from the southern state of Andhra Pradesh. The workers are trained in sculpting by Nek Chand and also supervise and sweep the garden. The cloth sculptures were being made for the High Court's Fiftieth-Year Celebrations in March 2006.

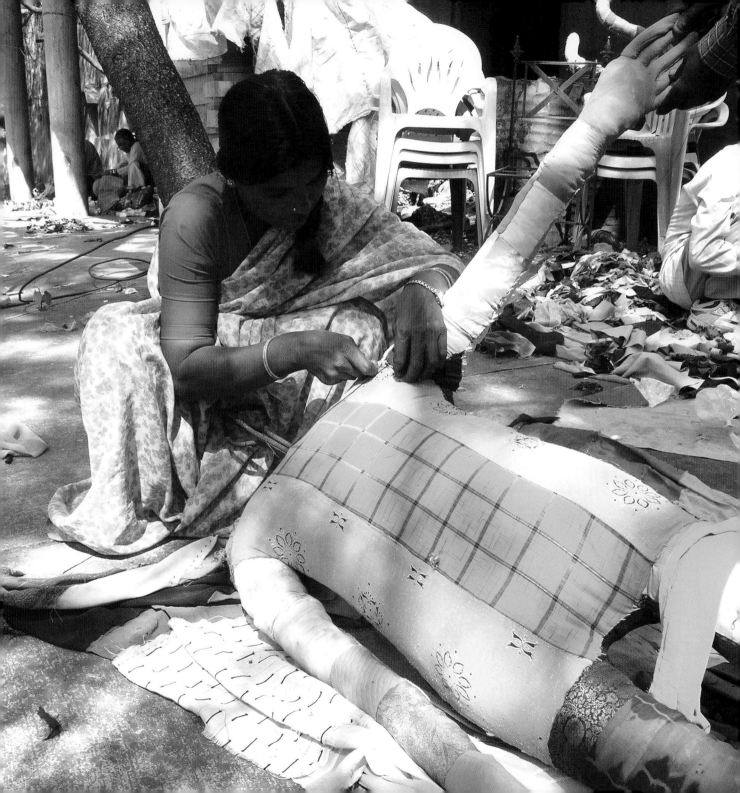

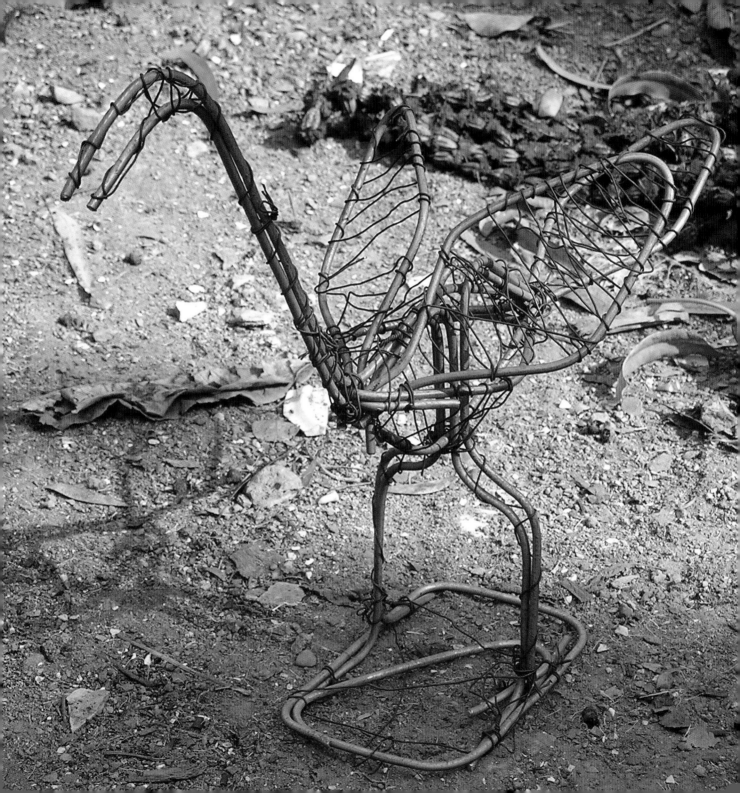

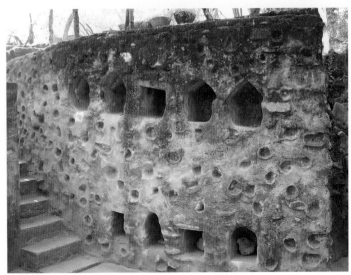

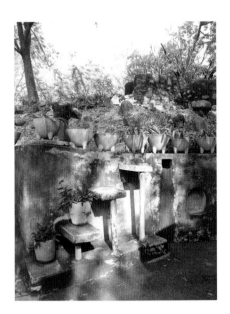

This page: These are the walls that define the courtyard area outside of Nek Chand's first hut. Into the walls are small niches, a feature that relates to traditional Punjabi construction methods. The presence of the niches illustrates how Nek Chand first saw this place as a domestic and intimate retreat for his family. Access into the courtyard was via the cast concrete steps (that now hold plant pots).

Opposite: The early sculptures produced by Nek Chand (before 1976) all had found armatures for structural support. These came from a variety of sources, such as old bicycle frames, exhaust pipes, leftover reinforcement bars and pipes. More recently the armatures are made with steel reinforcement bars with meshes and wires completing the framework. The reinforcement bars are a familiar and continual feature in Chandigarh as most of the buildings are reinforced concrete structures.

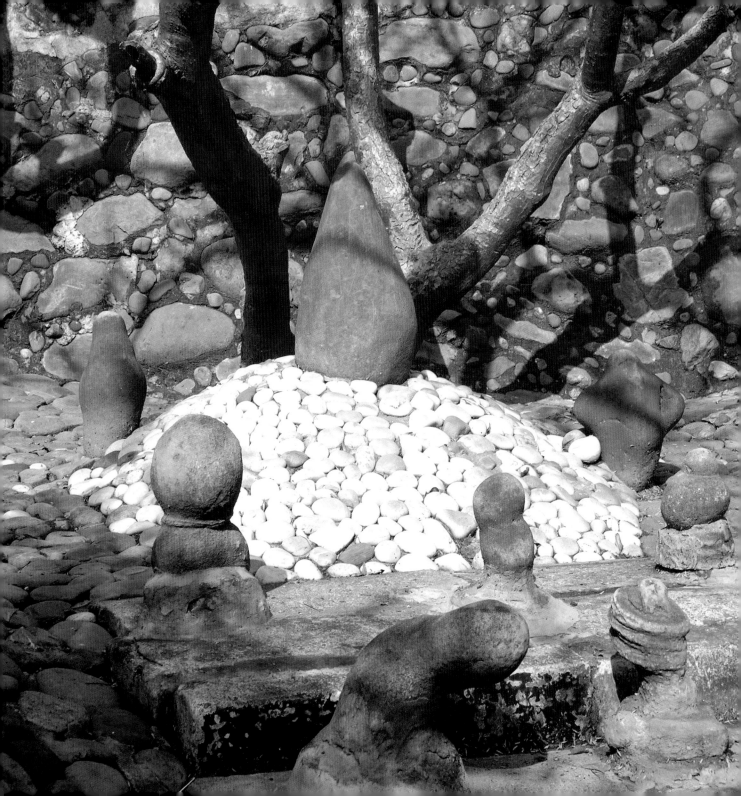

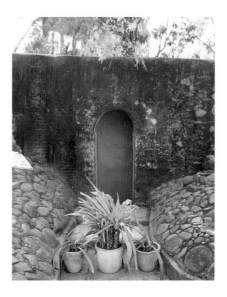

Left: This door was cast into the wall to give access into the new chamber behind it. The route has now changed and the doorway is no longer used, however it remains untouched like so many other passages, thresholds and displays in the garden. The physical presence of the garden's developments presents a kind of 'horizontal archaeology' throughout the site.

Left: The *lingam*, an aniconic representation of Shiva, and some claim a phallic representation. The *lingam* has been specially presented surrounded with white pebbles. The terrain at this time was simply clad in found rocks and pebbles as a means of demarcating the territory. The higher points of the landscape would be used as natural pedestals.

Right: There are several figurative bas-reliefs and incised motif drawings throughout the early sections of the garden, most of which are not on public display. They have been carved into partially cured cement render. The scenes depicted are predominantly natural or animal drawings with geometric patterns and prints. When the representations were created the garden did not have distinct 'public' and 'private' spaces, it was only because of the popularity of the site that prompted Nek Chand to distinguish between zones.

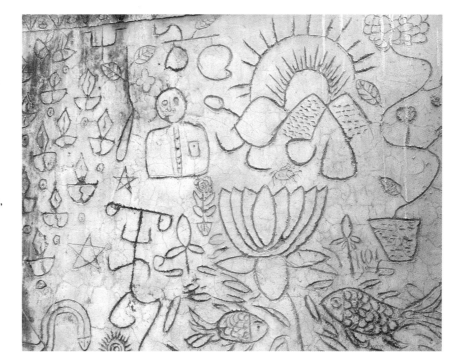

The screen is made from found metal wire held taught in a frame. Each wire has then been clad with small pebbles and cement. The effect is an ingenious semi-transparent partition that prevents the visitor from seeing what lies ahead. It also acts as a backdrop for a collection of rocks. The location of this partition in the first chamber possibly prompted the idea of presenting the garden as a series of smaller spaces.

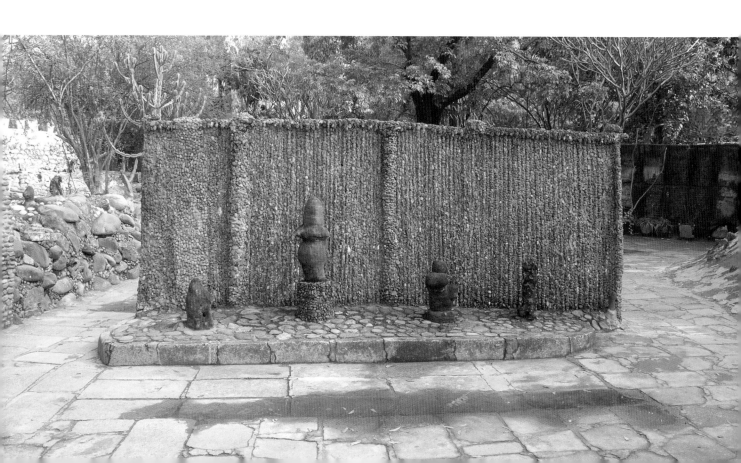

The collection

The following pictoral essay illustrates the principal focus of the Rock Garden: its collection of rocks and sculptures. As we have seen, the nature of the initial phase of Nek Chand's collection was determined by the logistics of transportation and was thus essentially small-scale. While no clear evidence exists, it appears that Pierre Jeanneret, the then Chief Architect of Chandigarh and a cousin and long-time collaborator of Le Corbusier, may have in part, influenced this passion of Nek Chand's. Jeanneret shared Chand's interest in raft sailing on Sukhna Lake and in collecting unusual found objects and rocks and wrote eloquently in support of the unusual, the found, the residual and the everyday in art and aesthetics (Jeanneret 1961: 56-57). Even Le Corbusier was a passionate collector of such material – objects, he said, stimulated poetic reaction (Benton 2006: 328) – which might have prompted him to situate an unusually shaped rock on a pedestal outside the City Art Museum in Chandigarh.

The rocks that Nek Chand collected – though suggestive of humanoid and bestial forms – were nevertheless ambiguous, allowing a field of rich speculation to emerge. Oscillating between the formed and the amorphous, these weather-hewn rocks and metal residues suggest light and dynamic qualities of the celestial dancers to the heavy, primeval and erotic forms of humanoids, the avian and the beasts. The sculptures he later produced soon found a new way of expression, shrugging off any connections with its predecessors' ambiguity of form. However, these retained one important characteristic of the collected rocks: their appearance in multitude. The infinite variations within an apparent uniformity of form and texture, which had drawn Chand to the rocks on the riverbed in the first place, offered him the opportunity to explore mass production of sculptures – apparently similar but ever so slightly different, prompting him to use stylised postures and gestures in his sculptures. Perhaps representing the Indian urban multitude – mass of uniform yet individual bodies – these form a choreographed composition, which stare back at the visitor with searching eyes silently asking questions.

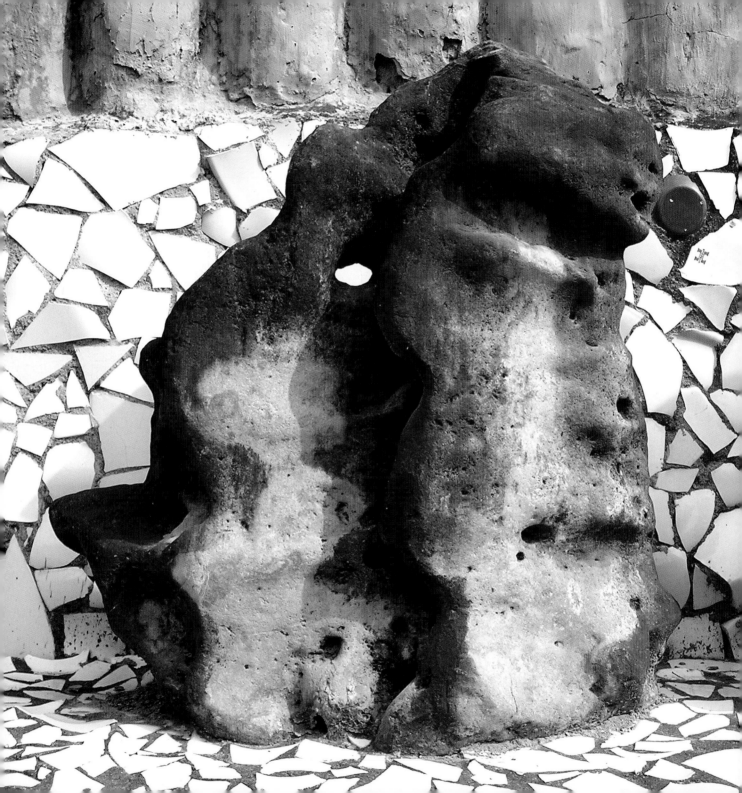

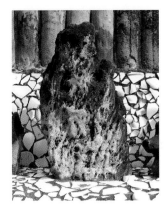
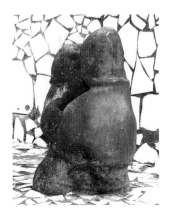

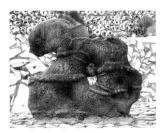
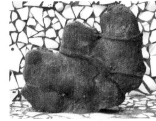

Nek Chand initially collected natural rocks to display in the garden. His interest in the rocks was shared with Pierre Jeanneret and Le Corbusier, both of whom collected found objects. The rocks shown here depict some of the familiar themes found in the rock collection, such as bestial, erotic and anthropomorphic representations (pp. 58-62). The rocks give different 'readings' at different times and within differing contexts, resulting from its inherent ambiguity, constructing a rich interpretive field. Different lighting conditions and shadows also affect resemblances and reveal previously hidden traits.

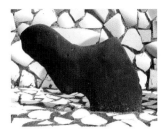
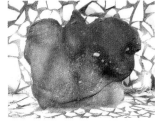

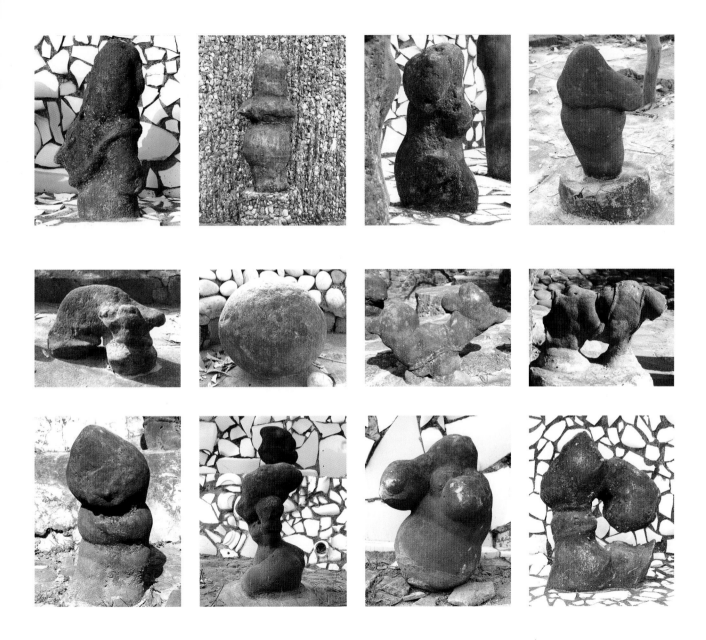

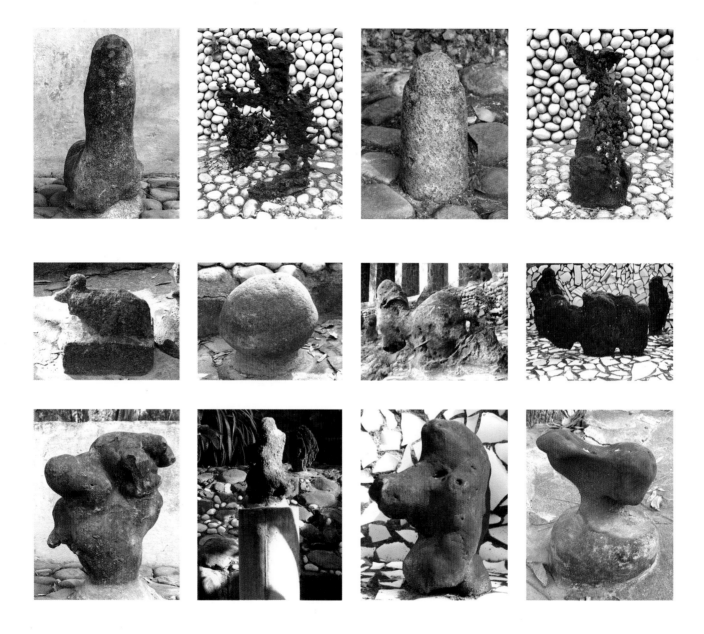

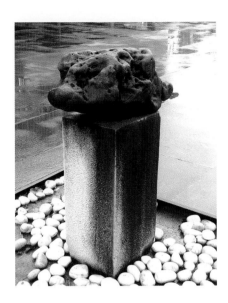

Above: A natural rock displayed on a concrete podium outside of the City Art Museum, Sector-10. Nek Chand's interest in the rocks was shared with Pierre Jeanneret and Le Corbusier, both of whom collected found objects that stimulate a 'poetic delight'.

Right: Jeanneret also published an article in 1961 about the aesthetic beauty of found objects in Marg magazine. The article discussed the two images shown here, one of a found rock and the other showing metal off-cuts arranged as 'modern art'. Nek Chand was also operating within this aesthetic field and time frame.

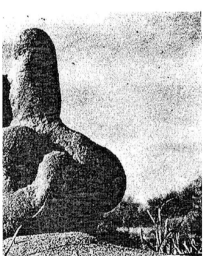

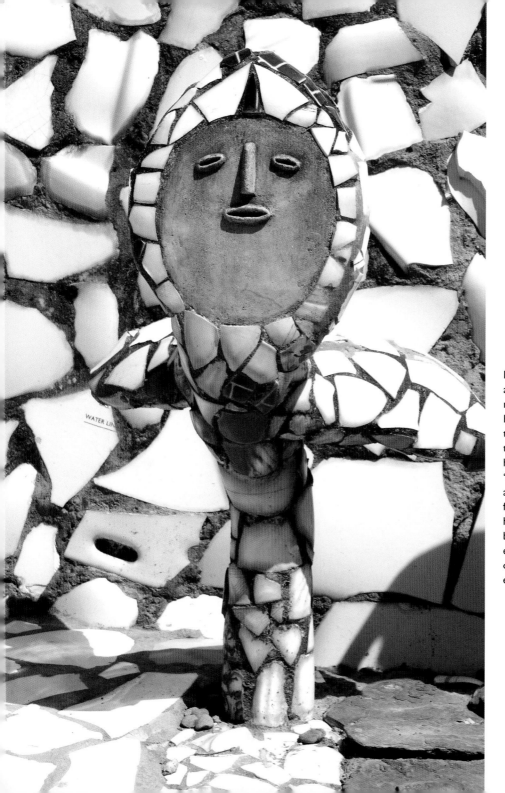

WATER LIL

Large portions of the early sculptures are difficult to 'read' or interpret as being representations of any particular object. However they have certain characteristics that suggest they are portrayals of living things. These sculptures, whilst often humanoid in form, exist ambiguously as 'between sculptures', neither human nor animal. They adopt certain anthropomorphic features that enable them to communicate human traits. The position of the heads, balanced on top of the arms and the facial expressions in some cases suggest avian or early-formed species emerging from an embryonic sack.

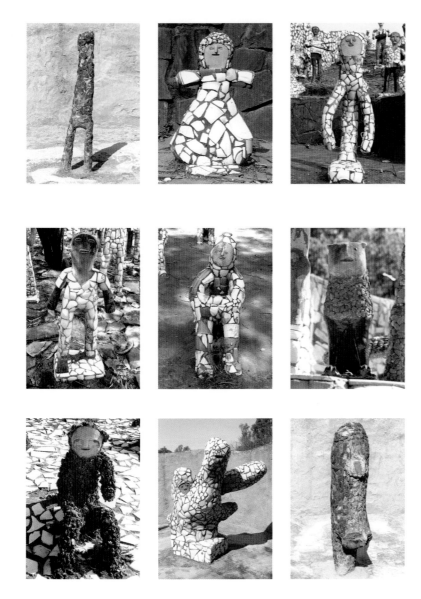

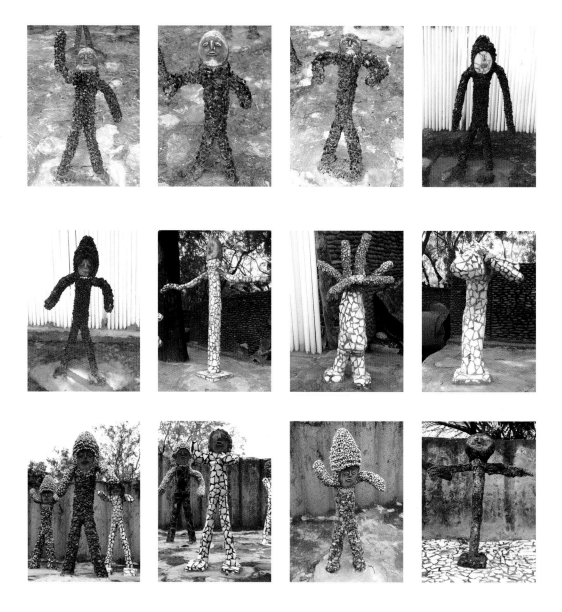

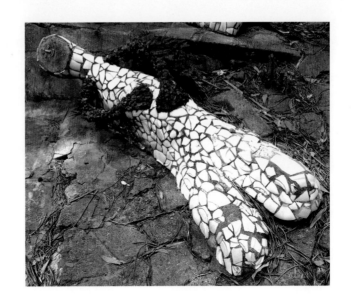

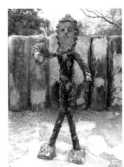

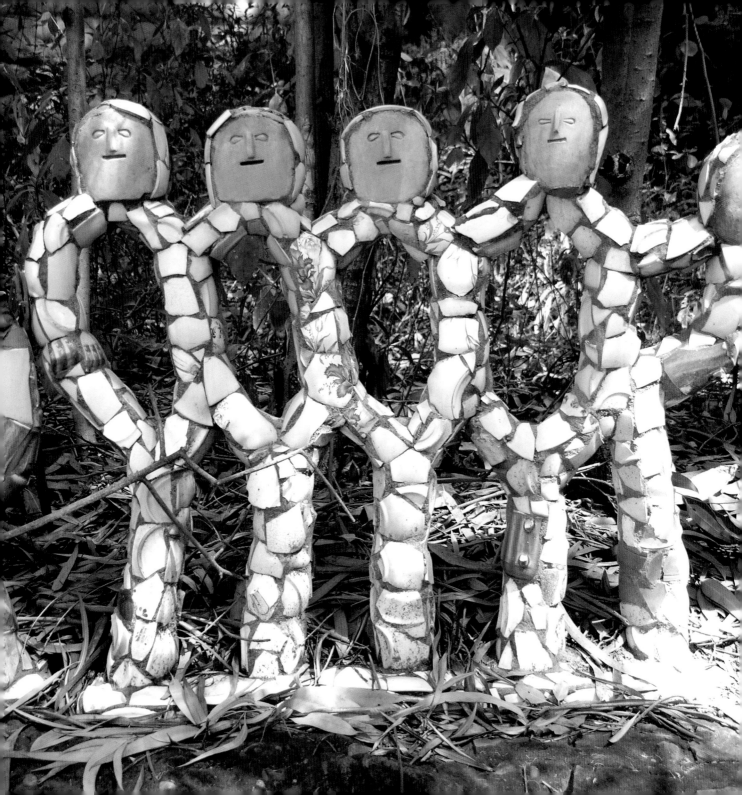

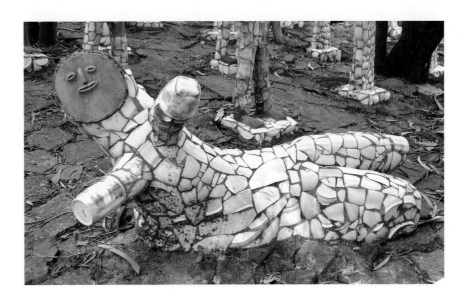

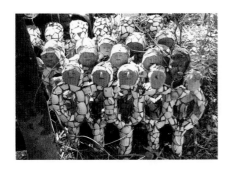

Over 60% of the sculptures currently on display in the garden are ones with humanoid form and facial features. The sculpting of the faces by Nek Chand has developed over time, starting with rudimentary depictions made of broken bangles. He began modelling the faces indicating the eyes and mouth with cement proud of the face. A significant development was to model the neck area. Initially the heads sat directly on the body for structural reasons. Following some experimentation the head could be properly supported on a thinner neck, enabling a chin to be modelled and a face to be expressed as a component of the head. Additional features such as 'hair' were added and skin pigmentation created by mixing brick dust with the mortar. Nek Chand also began to model the eyes differently to the mouth, using shells or broken shards of ceramic to form the eye and modelling the brow and cheekbones with cement. The sculptures have become less ambiguous as a result of this process and more readily interpreted as human representations. This research project has also considered the development of the posture, gesture, and attire of the sculptures.

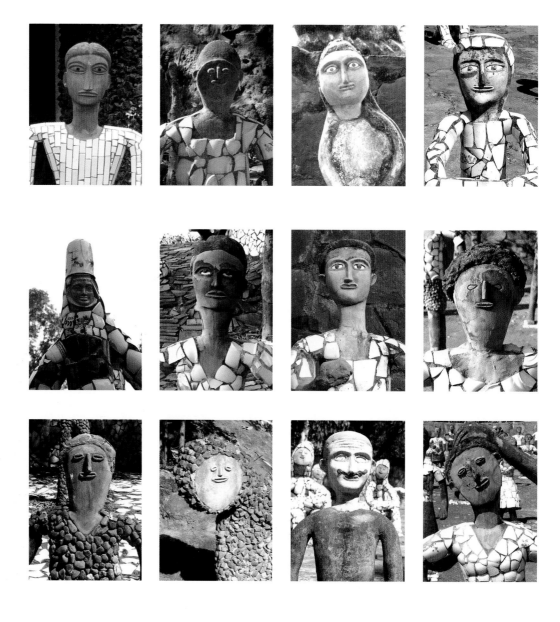

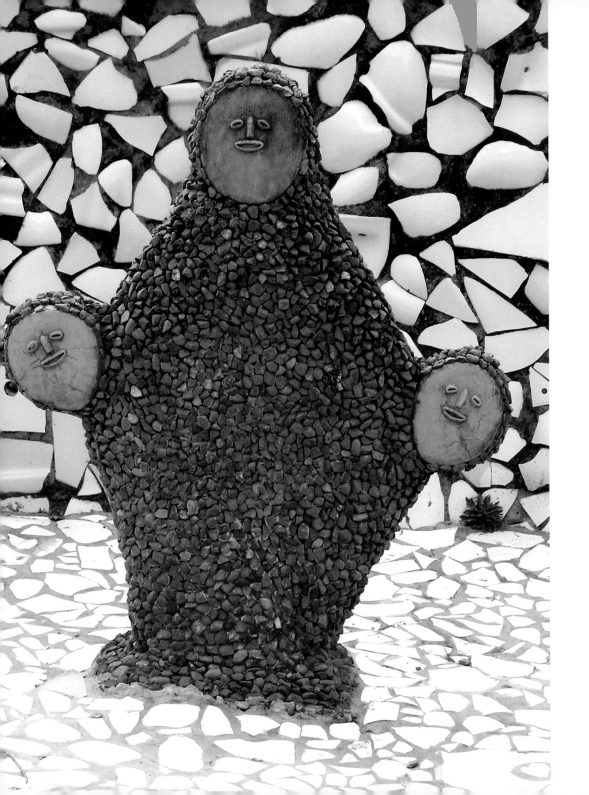

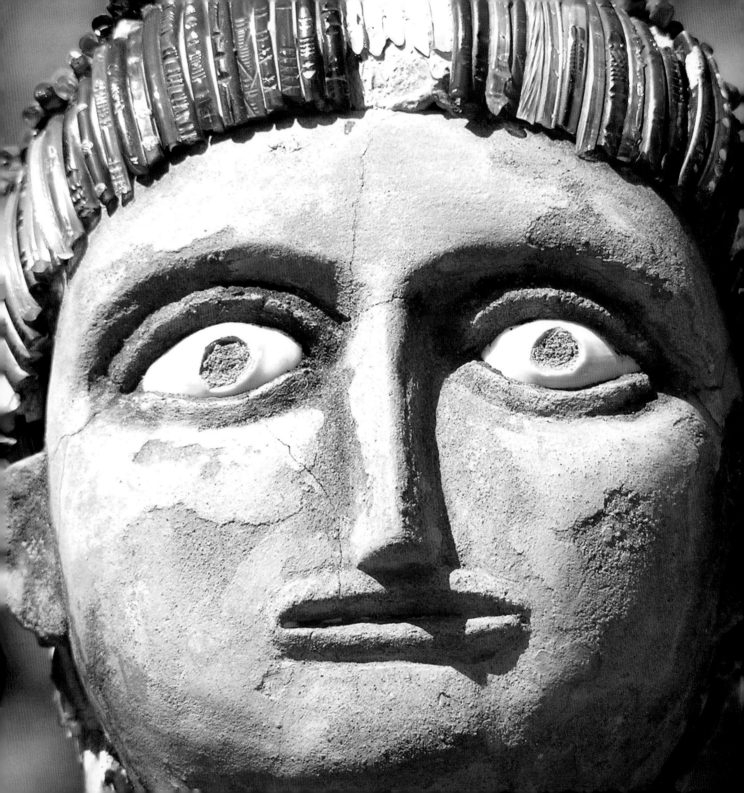

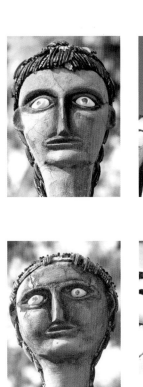
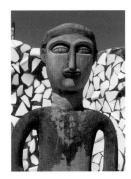
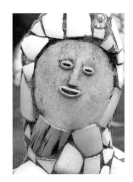
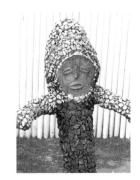
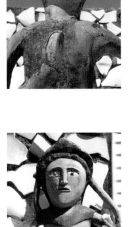
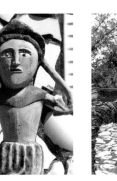
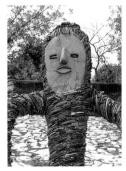
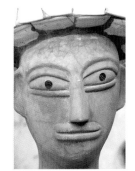
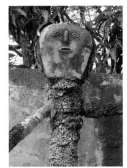
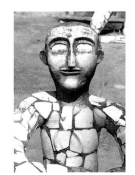

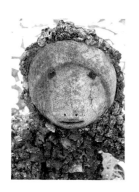
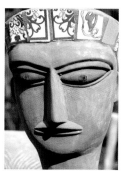
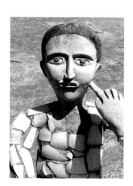
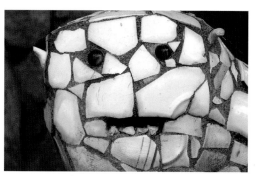
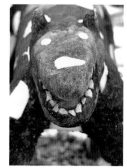
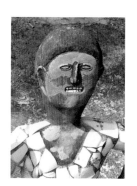
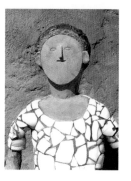
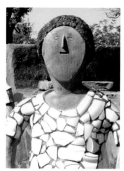

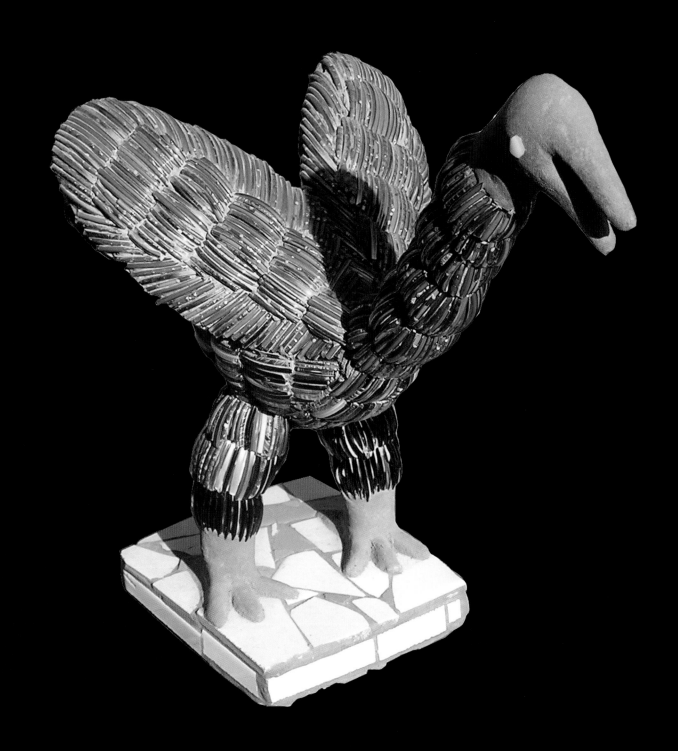

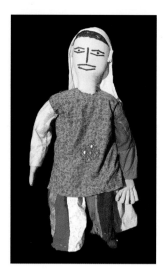
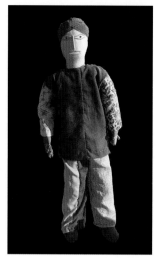
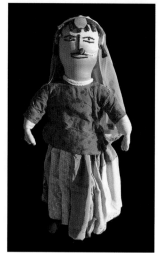
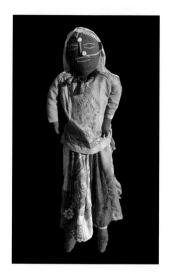

Above: Cloth sculptures produced in the Rock Garden, 2006. Metal armature with salvaged rags. In private collection.

Right and previous: These small birds were made in 2004. Metal armatures, cement, brick dust, glass bangles, and ceramic. In private collection.

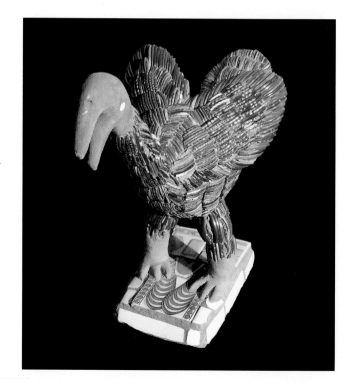

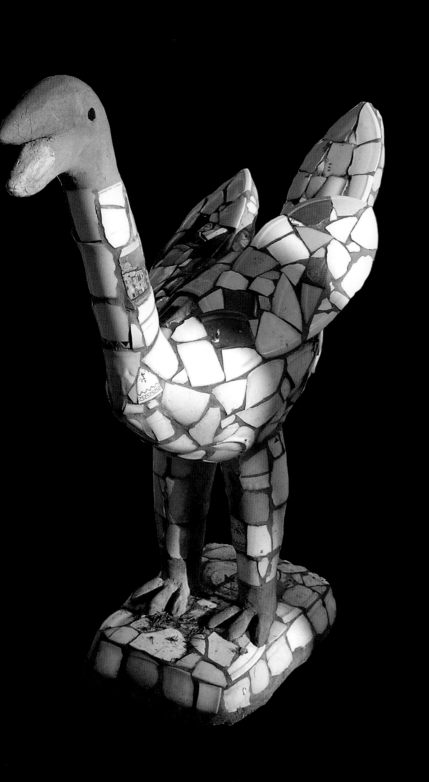

Ceramic-clad bird. Metal armature, ceramics, cement and brick dust. In private collection.

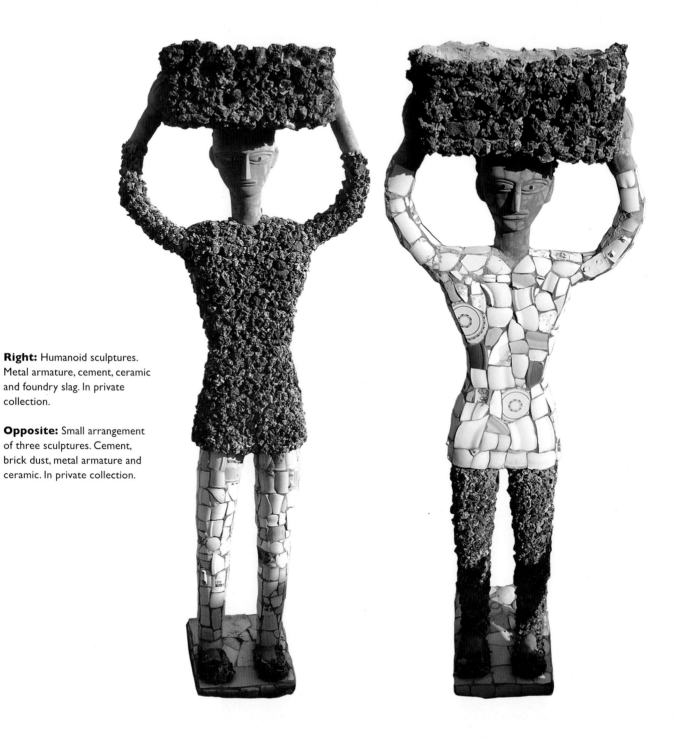

Right: Humanoid sculptures. Metal armature, cement, ceramic and foundry slag. In private collection.

Opposite: Small arrangement of three sculptures. Cement, brick dust, metal armature and ceramic. In private collection.

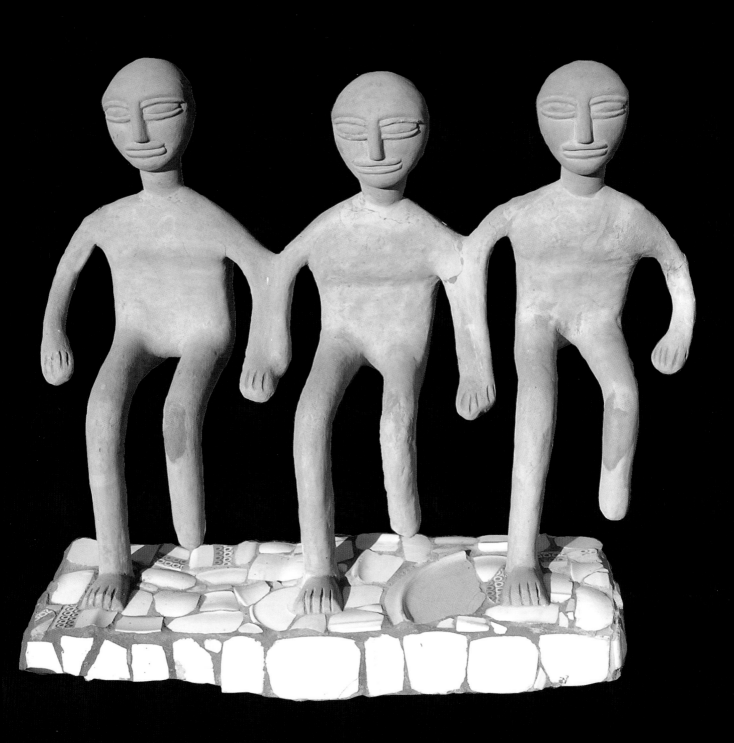

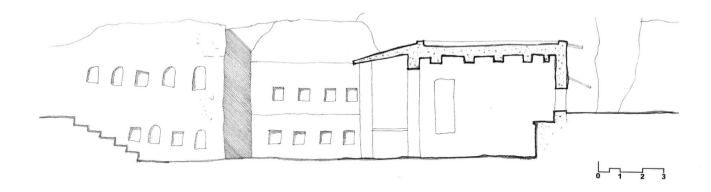

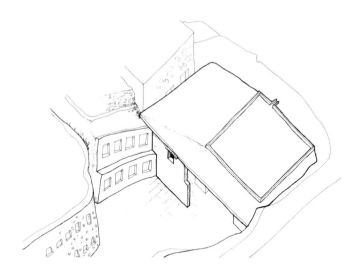

The first hut and courtyard were only displayed to the public after 1980, being transformed from a functional space into an artefact. It also marked a departure in terms of how Nek Chand and his work were perceived within the public domain. His modest hut, now transformed into a cultural commodity, began to be seen as a special component of the garden. Nek Chand's workspace continued to shift through the garden, as he constructed huts as the garden expanded. They became 'mapping rooms' for charting the territory and marking ownership of the site.

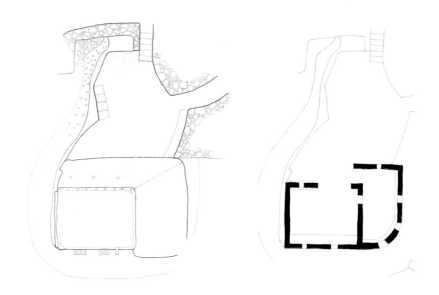

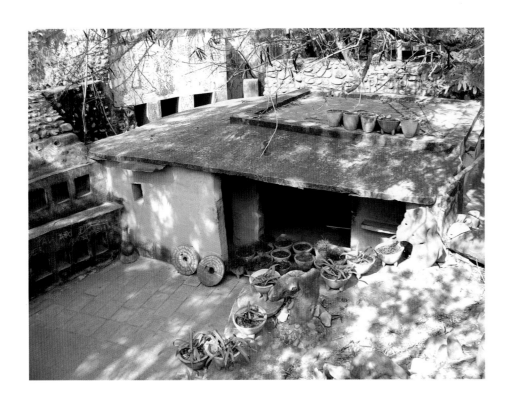

Right: The Rock Garden's first chamber, indicative of the essentially secretive nature of Nek Chand's early activity with the resultant enclosed introspective space. This space held the initial rock collection as well as the 'ponds' excavated by Nek Chand as reservoirs to hold water for the cement mixes. A variety of materials were used to clad the walls and structures, including plastic electrical mouldings and terracotta pots. The podiums and display pedestals are smaller in the early areas of the garden as Nek Chand was working alone at that point.

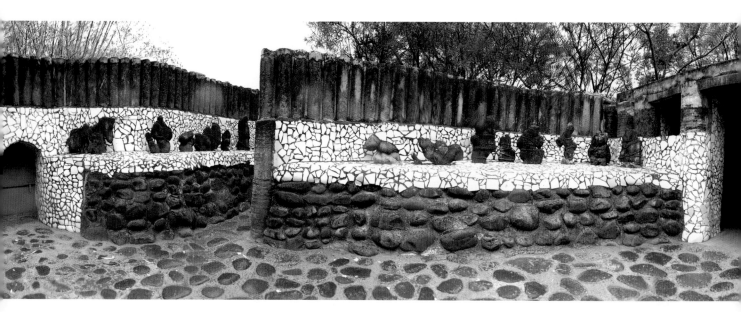

Above: An early chamber in the Rock Garden showing some of the natural rock collection. The panoramic photograph also shows the initial gatehouse. Note the concrete walls cast into oil drum formers.

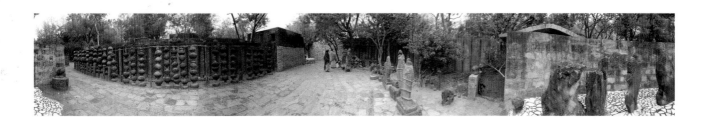

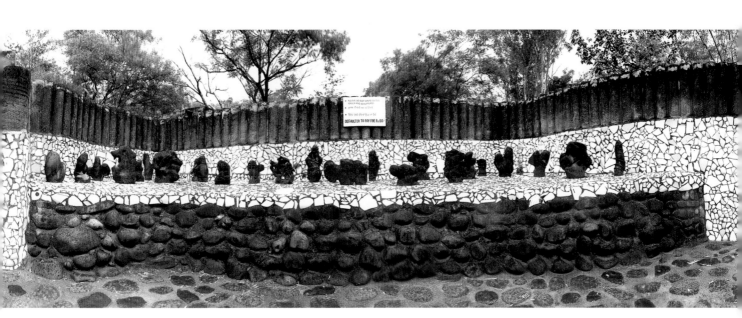

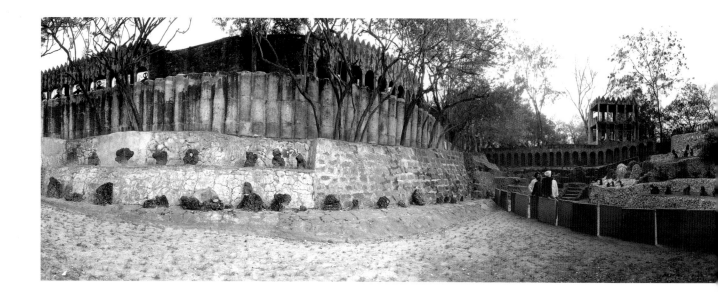

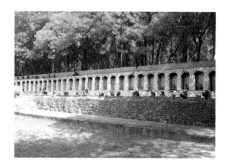

Above: A large collection of natural rocks set into a modified landscape. Surrounding the chamber is an earlier perimeter wall cast into oil drums and now extended to display several follies and castle-like buildings.

Right: View into section-I from the surrounding follies.

Left: A series of niches clad in broken ceramic and forming part of the old perimeter wall. The niches mirror the arcade on the opposite side of the chamber.

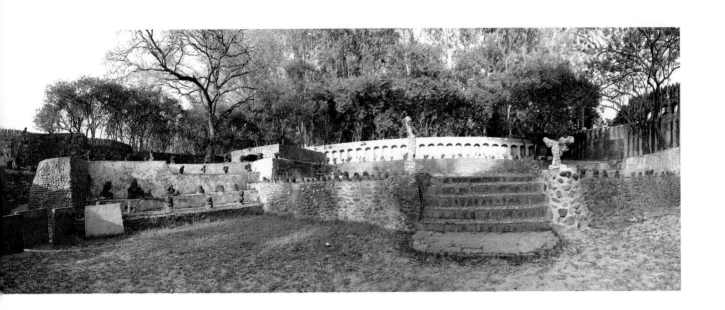

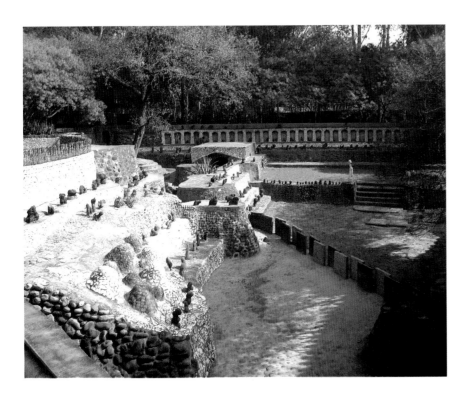

The collection, the ruin and the theatre

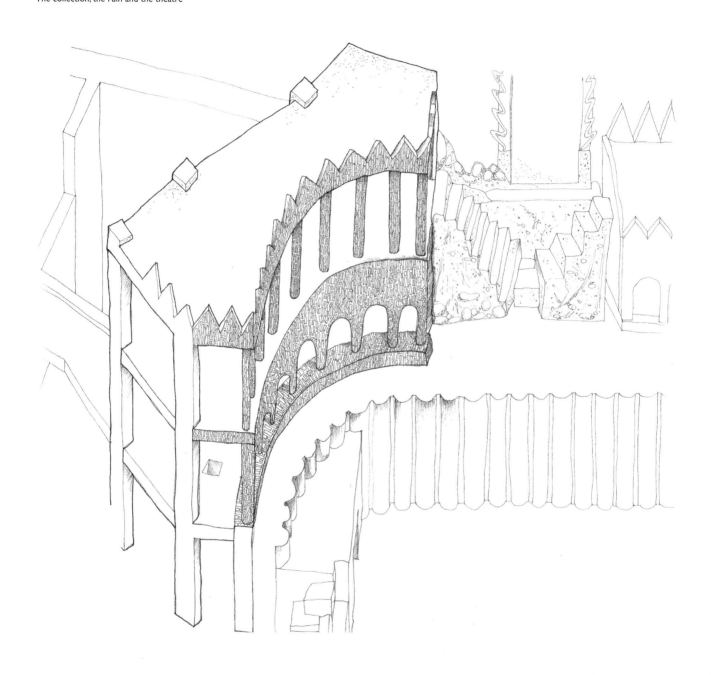

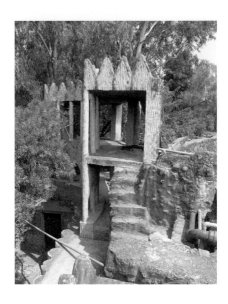 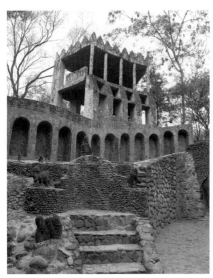 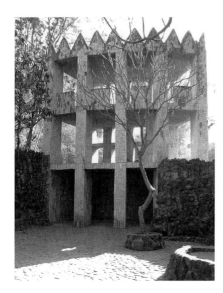

These deceptively simple structures bridge changing levels in the topography and look considerably different when viewed from different angles and vantage points. Like most structures in the Rock Garden they are formed with a series of columns that hold up the floor slabs. Towards the base the columns are reinforced with buttresses and arches, whereas higher up the structure a more delicate and lighter approach is taken. The follies are finished with brick-inset roofs and triangular castellated parapets.

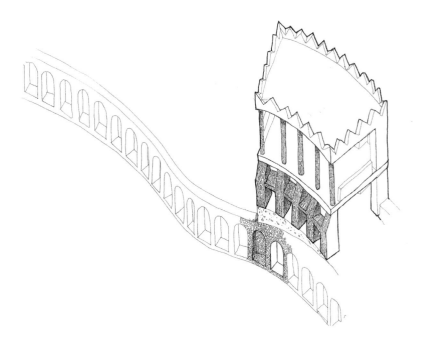

The collection, the ruin and the theatre

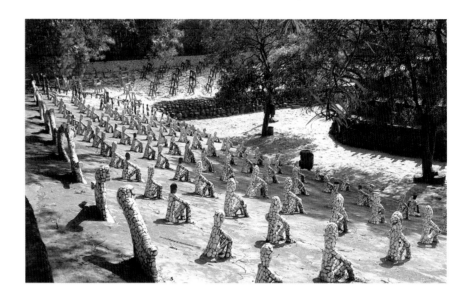

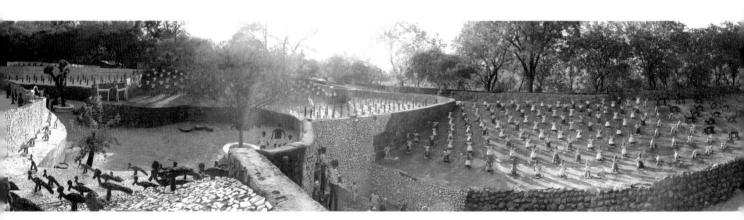

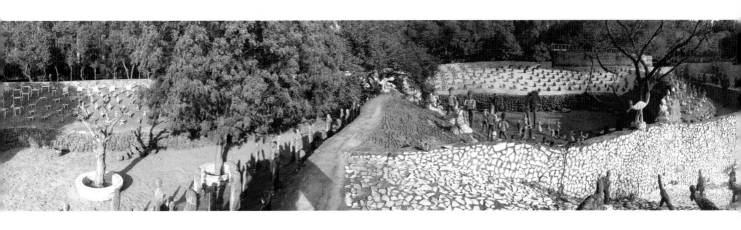

Nek Chand built his own 'display case' to
exhibit his work. The sculpture collection
is arranged in an amphitheatre-like setting
divided into smaller chambers. The
sculptures are arranged alongside other
sculptures of a similar type. This photograph
is taken from the central podium looking
down towards the visitor's walkway.

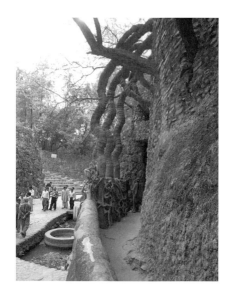

Section through the structures that form
the extents of section-I and face onto
section-g.

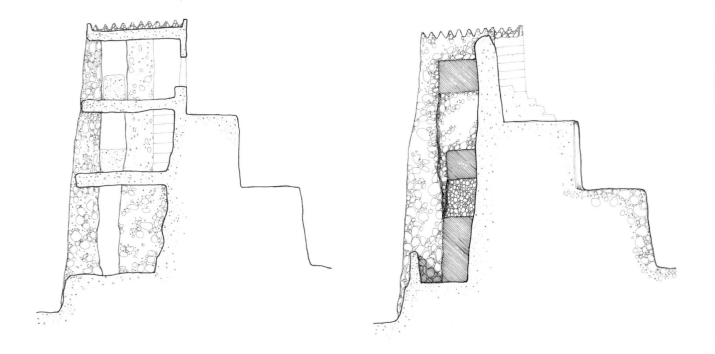

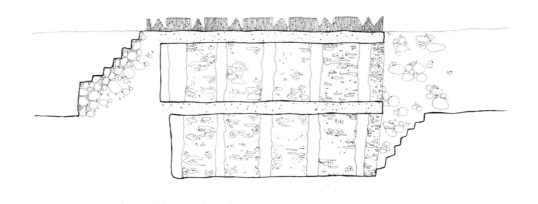

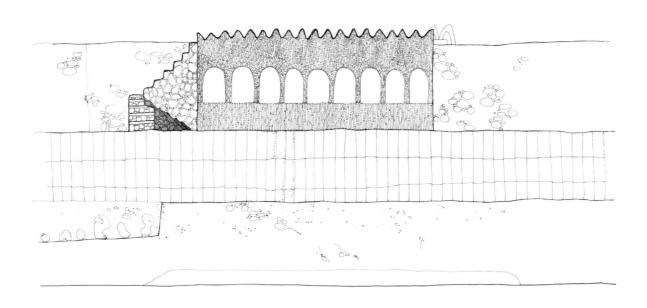

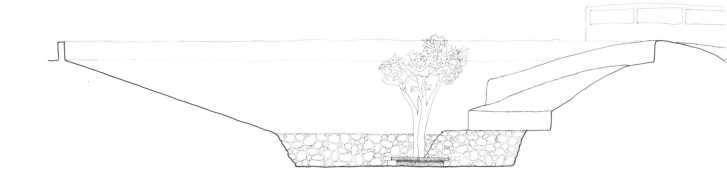

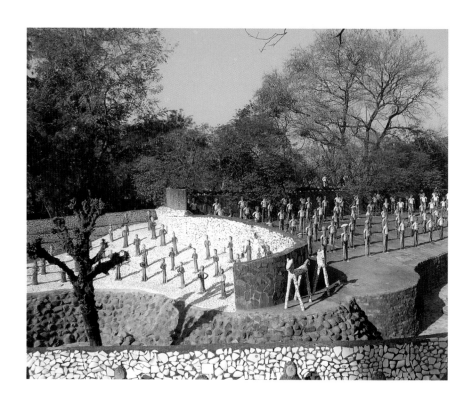

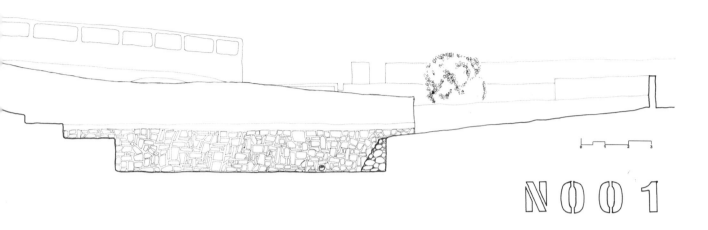

N001

Left and right: The sculpture collection in Phase-2. Multitudes of sculptures are displayed on terraces and podiums. A sculptural menagerie is exhibited, including dogs, birds, deer's, cattle, horses, monkeys, peacocks and camels. There have been no permanent sculptures added to the collection here since 1980. All the new sculptures are kept in the workshop areas.

Above and overleaf: Sectional drawings cutting through the landscaped display case. The existing mounds in the topography have been clad or shrouded in ceramics, stones, slate and render to form a base for the exhibition. Often a contrasting colour or texture is used for the cladding to accentuate the features of the sculptures. These drawings show the complexity of the landscaping and the multilayered approach in dealing with the garden's topography.

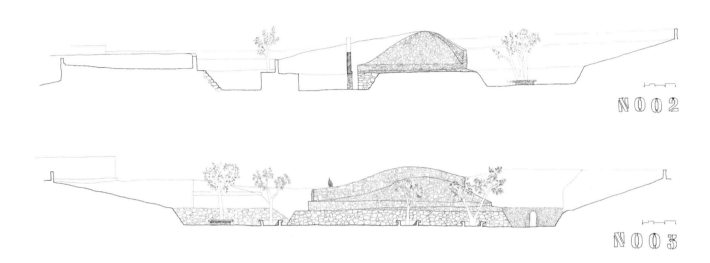

N002

N003

Right: The sculptures are exhibited on the central mound and on the raked podiums that form the periphery of the enclosure, the visitors' route passes through the central aisle. It is almost as if the roles are reversed and the visitors are put on display themselves, watched intently by the throng of sculptures fixed in a permanent stare. They ask questions.

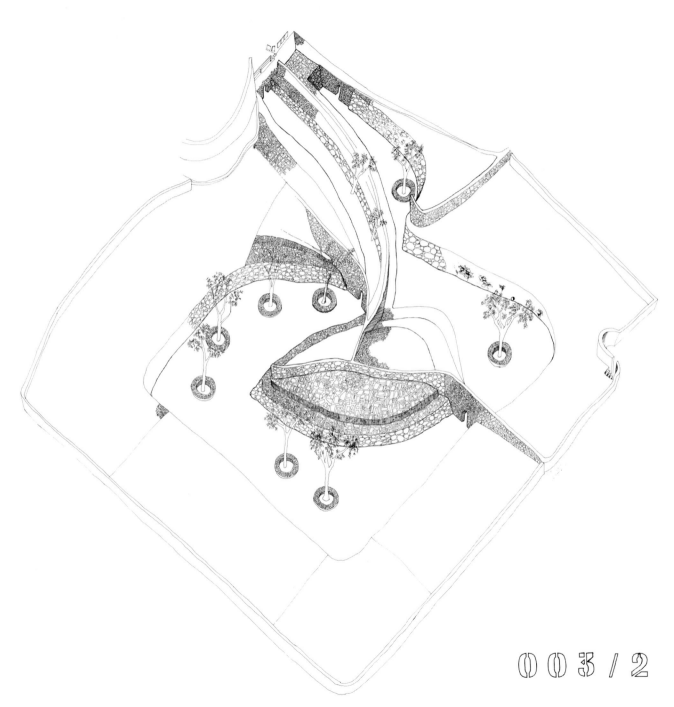

003/2

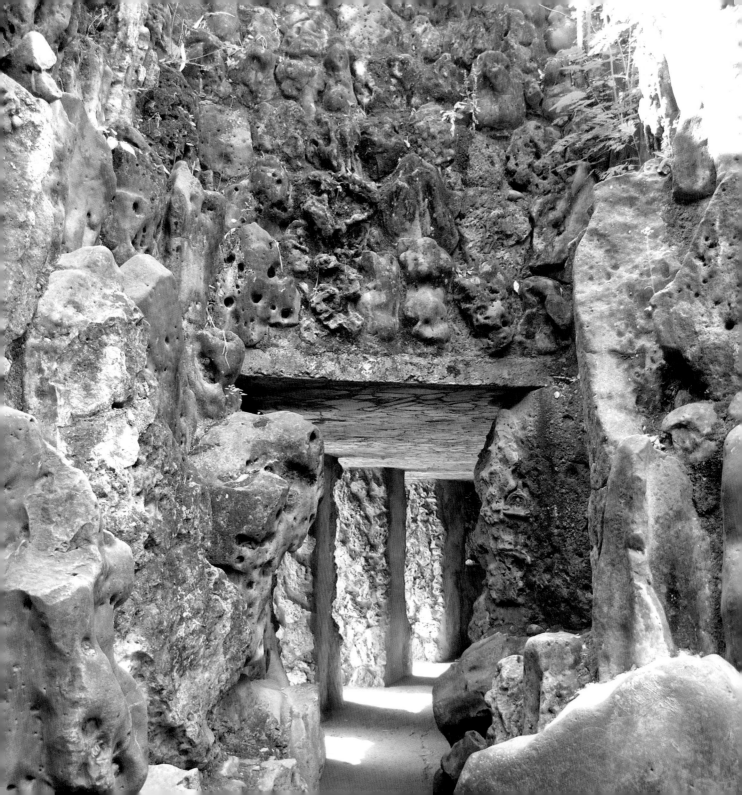

The ruin

We have already indicated the importance
of the 'unfinished' in Le Corbusier's work
at the Capitol Complex in Chandigarh. He
sought to embody the architectural image
appropriate for the newly independent
country and the ambition of the future in
the 'incomplete' or more appropriately,
in the 'ruin'. Arguably such a conception
emerged out of an enduring presence in
his mind of the Acropolis and the ruins of
Fatehpur Sikri and thus exuded a Romantic
pleasure found in some of the early-colonial
paintings by the Daniells. Nek Chand did
not want to create a 'garden of cold rocks'
but to manifest 'a child's dream' (Tribune-
news-service September 2 1996), which
explains the miniaturised nature of the
early phase of the garden. Fusing dream-
fantasy with a sense of deep loss – perhaps
a manifestation of the loss of ancestral
home that Chand and his family suffered
during the Partition in 1947 – he created
a desolate world of beautifully crafted
miniature huts heralding the beginning of

his fascination with ruins. Latent in this
was also a fascination with fabricated
archaeology as a creative opportunity,
the inquiring potential of which we have
already discussed. Huts that Nek Chand
once used as workshops – now desolate
and commodified – lie dotted around the
garden, acting as footprints in the Garden's
passage from secret beginnings to acclaimed
touristic attraction. The pure unadulterated
joy of child's play producing architecture,
landscape and sculpture without
preconceptions has slowly given way to a
more conscious play with large-scale sham
ruins. Redundancy and the contingent,
which Nek Chand so skilfully and cleverly
employed as ingredients in his early work, is
now writ large as the work itself.

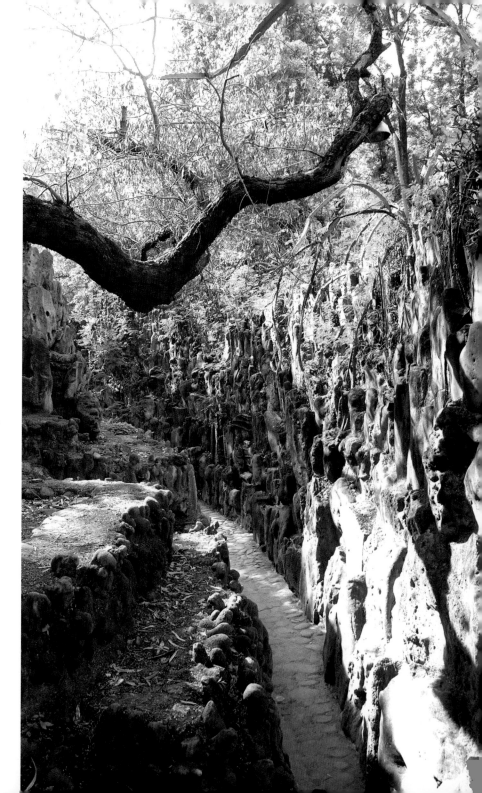

This page spread and previous:
Built between 1980 and 1983, this narrow
passageway invokes the spatiality of the
settings of Ajanta and Ellora rock cut caves.
The natural rocks are now presented in
multitudes rather than individually, as they
were in the early parts of the garden. The
route of the passageway contorts, and
constricts the visitor, hiding the destination
point that is finally revealed only in the last
few metres of the journey. The proportion
of the pathway width to the height of the
side walls creates the feeling of passing
through a sunken gorge or canyon. The
rocks are deliberately positioned to reveal
'faces' and 'body forms'; fragments of
possibly domestic shrines are also set into
the rock face.

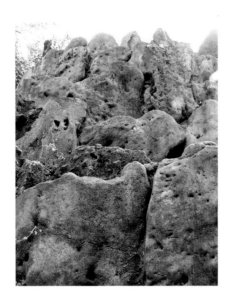

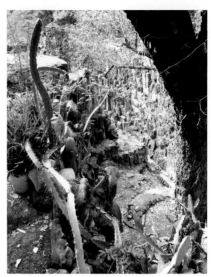

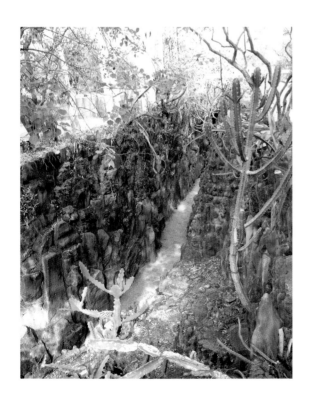

The collection, the ruin and the theatre

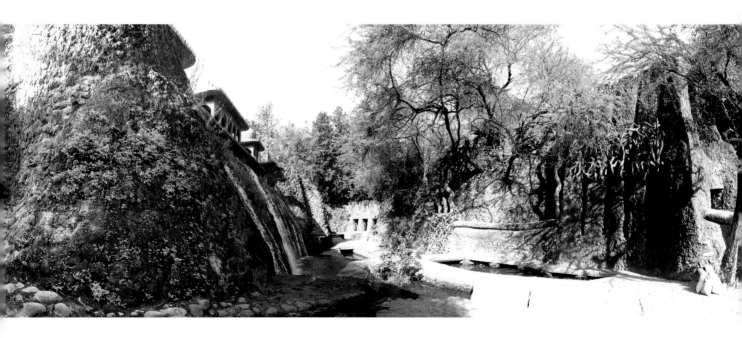

Panoramic photograph of section-g. The waterfall and Mughal-style *chhatris* invoke a paradisiacal setting.

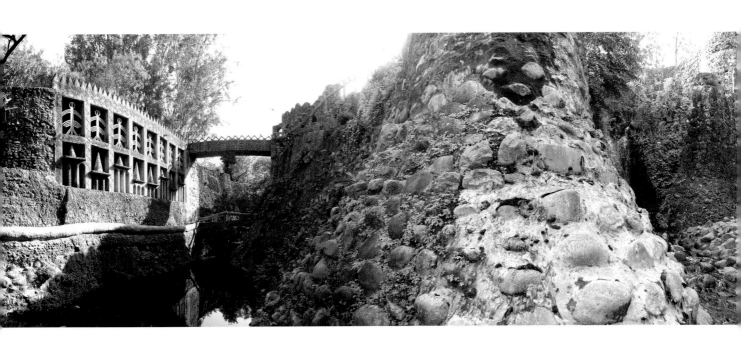

Below: A sectional view taken through section-g and section-i. The water tanks for the waterfall are shown on the upper right-hand side of the drawing. On the left-hand side is section-l. Note the shift in scale between the two sections. Section-g is far larger and less dependent on the original topography of the site.

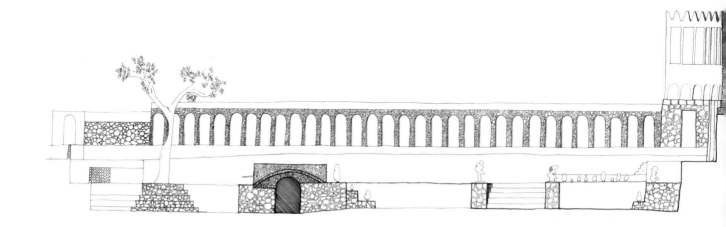

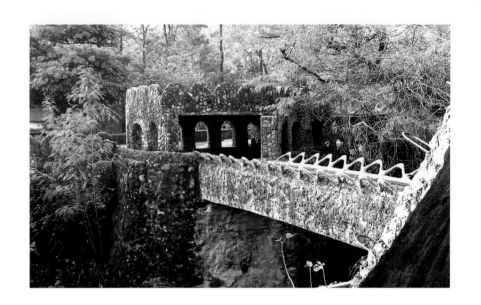

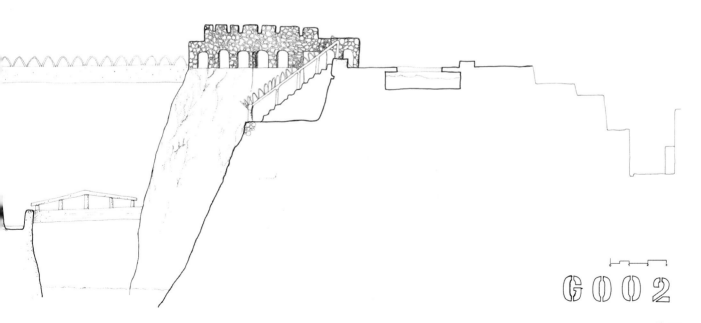

G002

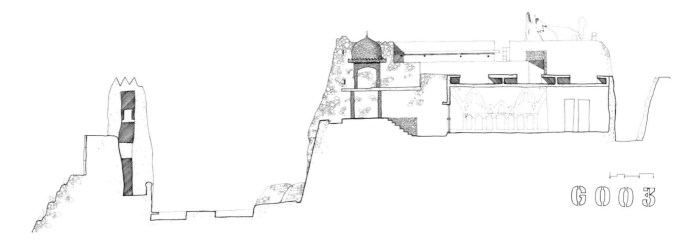

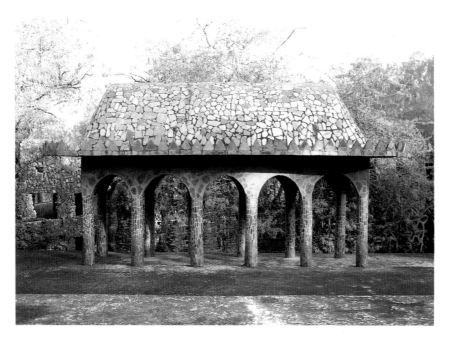

Above: This section is taken through the guesthouse, a cleverly inserted piece of architecture, and waterfall of section-g. The arcade and *chhatri* are also shown. Nek Chand has worked with the different levels in the topography of the site to create the height for the waterfall. There is a slight hint that Nek Chand shares Le Corbusier's fascination with roofscapes.

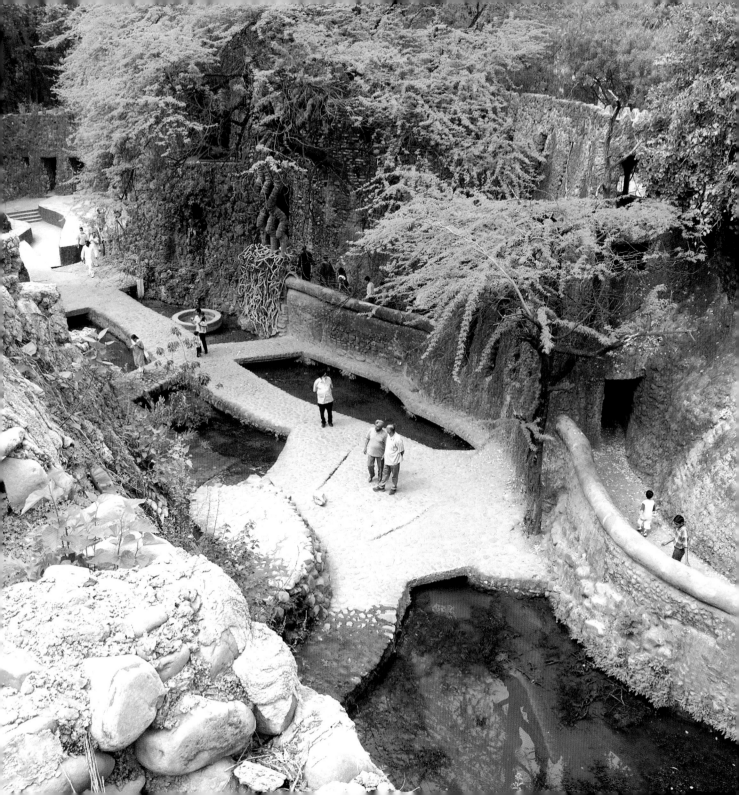

Below: Adjacent to the first waterfall is a mosaic depicting various animals and a large tree. These figurative illustrations stem from the initial bas-relief work and are developed further in the third phase.

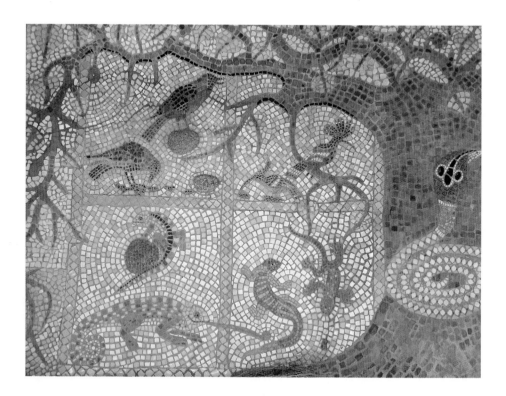

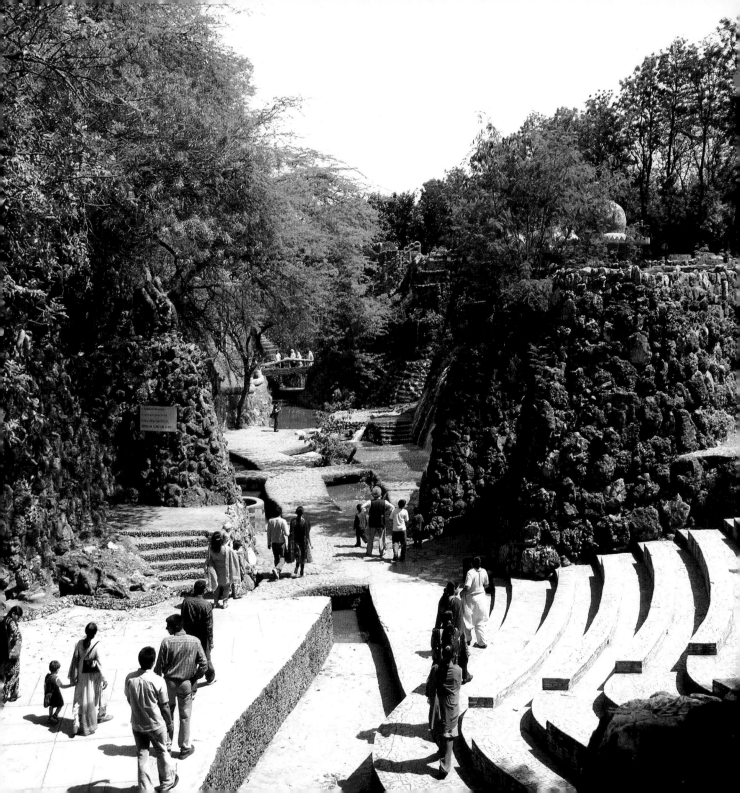

The collection, the ruin and the theatre

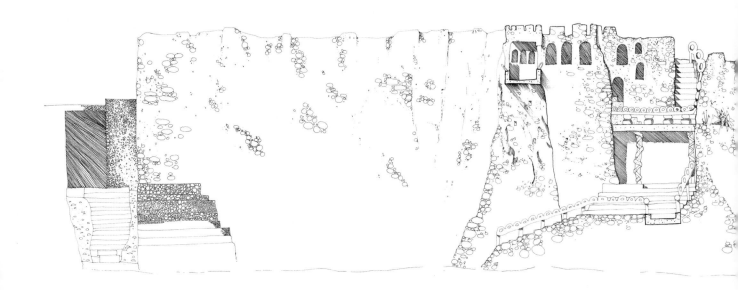

Below: A longitudinal section showing the elevational treatment of section-g. The three *chhatris*, arcade and waterfall are shown as well as the grotto and castle-like structure. This 'settlement' or 'sham ruin' invokes a lost kingdom. Plants and trees are cultivated in the walls to create the feeling of old dilapidated structures. Behind the façade are the water storage tanks that feed the waterfalls. The structure is made from natural rocks, cement and hidden brick pillars. None of these buildings or structures are accessible to the public. They are presented as large-scale sculptures. The water that flows through this section of the garden is a natural feature of the site that Nek Chand integrated into his design.

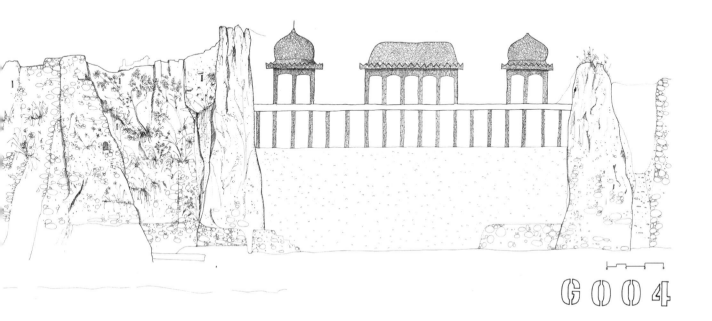

G004

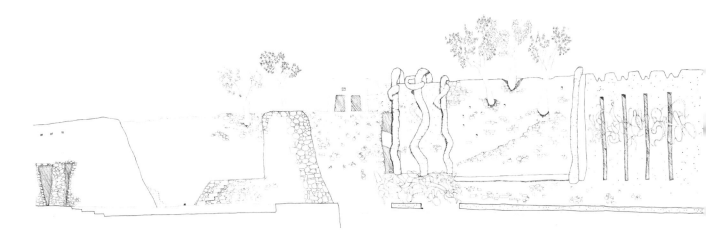

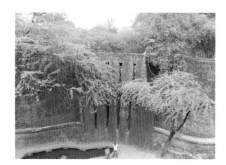

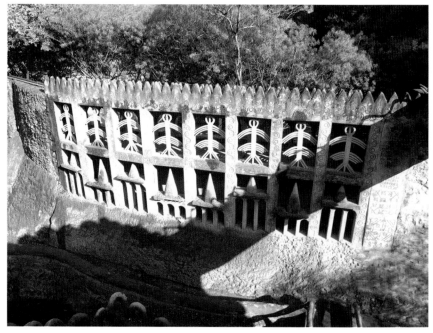

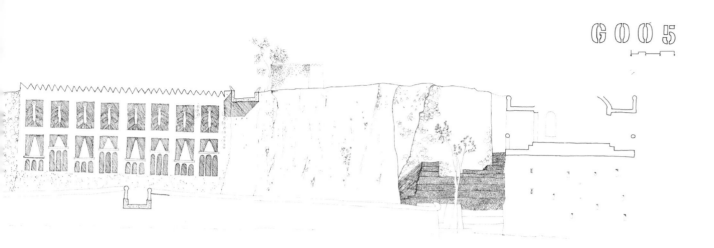

Above: A sectional drawing looking the opposite way to G004. This shows the elevational treatment applied to the structures in section-g. None of these buildings are accessible to the public. Some are used by Nek Chand's staff as storage and others are non-functional structures often only 600 mm deep in plan. The façades are all made from concrete cast *en situ* with inset rocks. Concrete trees and roots penetrate through the façades as well as real trees that are beginning to force apart the structures. These components contribute to the 'ruined' and historical feel of the garden. The visitor can pass through some of the structures at ground level with views back towards the waterfall.

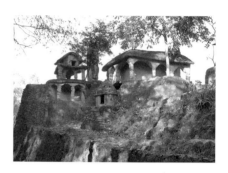

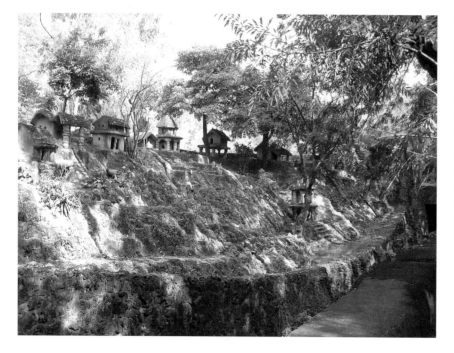

The 'model village' was constructed between 1980 and 1983 and is located behind the first waterfall. It consists of around twenty dwellings made from cast concrete set onto a raked landscape with stream, natural rocks and plants. The arrangement and its desolation evokes a distant village scene, perhaps where childhood memories coalesced and intersected with the difficult memories of Chandigarh's establishment through the destruction of extant villages on site. This is the only place where beautifully crafted small-scale representations of buildings are found in the Rock Garden.

The theatre

The Garden transports us to another world – a liminal world of fantasy and fabricated myths – configured by a primitivity that has eventually subsumed traces of its post-independence host (Chandigarh) using overt representational devices. Beginning with its earliest displays of rock collections, the Garden engages us in a theatrical performance, which becomes increasingly vocal as we move towards the later phases. This could be regarded as a manifestation of the overt theatricality present in Punjabi life and popular culture, to which Bollywood has often turned for inspiration. In fact, the Rock Garden contains three amphitheatre, which have been used for popular gatherings and weddings. The groupings of rocks and sculptures create theatrical settings and enactions, luring the visitor into the act through their initial curiosity. The visitor is taken from one chamber to another in a manner that reminds one of the traditional form of Indian theatre (*jatra*). Thus attracted, they inadvertently become

part of the act itself, completing as it were, the 'fourth wall' of the theatrical space. It is only then the visitor realises that the low arches providing entry into the Garden and its various chambers are in fact clever miniaturising devices subjecting them to enter the diminutive realm of the rocks and sculptures and continuously reminding them of its otherness and liminality *vis à vis* Chandigarh.

Nek Chand preserves and extends this otherness by the employment of a workforce characterised by a range of 'disabilities' or 'abnormalities'. Lokram, who has devoted his life to the service of Saabji, is of an unusually small stature, while the PWD workforce Nek Chand inherited were largely recruited from the southern Indian state of Andhra Pradesh and thus could speak little Punjabi – the local language, or even Hindi. Located at the northern end of the city, the Rock Garden closely contests another theatrical setting next

door: the Capitol Complex epitomising the theatricalised processes of Nehruvian decolonisation. Over time the buildings of the Capitol, in itself, have become settings for endless political theatre and wrangling, as Punjab has painfully trudged through wars with Pakistan, the religious upheavals of the 1980's, but most importantly, its fracturing into three states that include Haryana and Himachal Pradesh. The latter has resulted in the shared use of the Capitol located within a territory administered directly from Delhi, putting Chandigarh in an ambiguous status *vis à vis* other Union Territories, such as the erstwhile French colony of Pondichery.

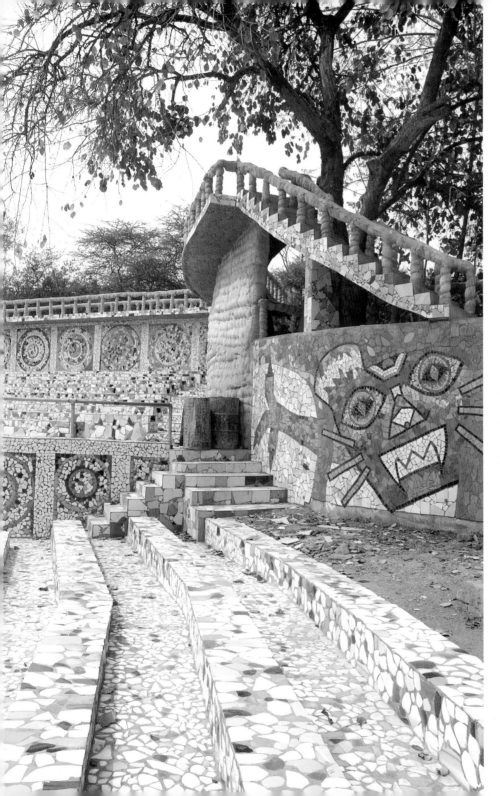

The largest theatre in the Rock Garden is located in Phase-3, capable of seating in excess of one thousand visitors. It is clad in broken ceramic and the backdrop to the seating is a combination of mosaic *Mandela* patterns and figurative illustrations. The seats look out onto the esplanade towards a circular dais in the centre of the space. In addition to providing seating the terraced arrangement acts as a retaining wall, bridging the shift in levels within the topography.

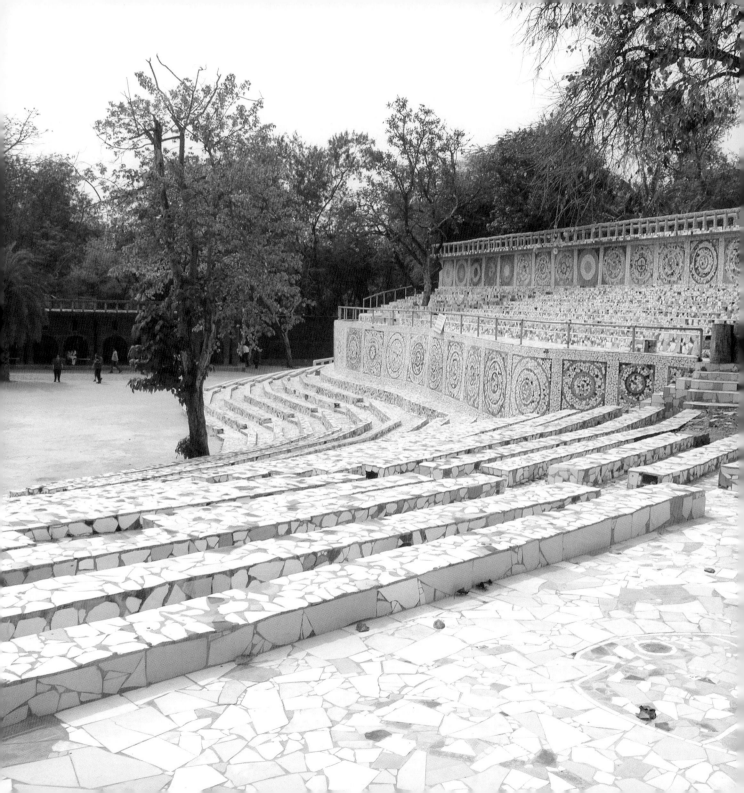

The collection, the ruin and the theatre

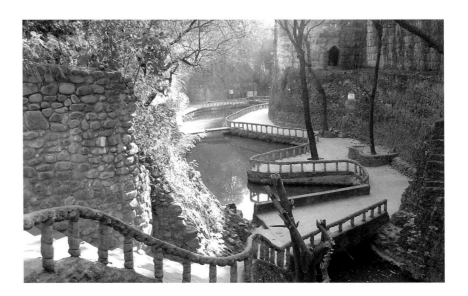

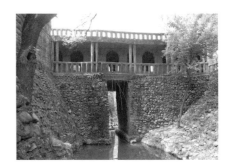

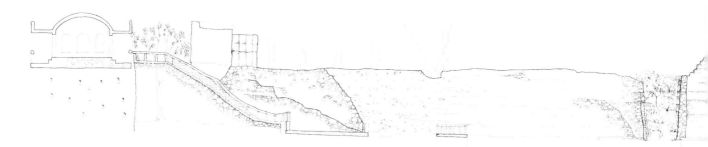

Left: Entry into Phase-3 is via a long cobbled corridor that eventually opens out to reveal the largest waterfall in the Rock Garden. The route winds through the watercourse with large cast-concrete structures on each side of the path. The concrete is cast into hessian sacks giving it a cushion-like appearance. The waterfall is stepped to slow down the rate at which the water cascades and creates a loud and dramatic effect. At the pinnacle of the fall is a statue of Shiva depicted with the trident and serpent. The waterfall is also a reference to Shiva's matted hair, which in popular mythology is said to be a thick flowing river or waterfall. It is also of note that Shiva is said to reside in the Himalaya that are visible from the top of the structure.

Below: Sectional drawing through the initial section of Phase-3. The waterfall is shown in elevation along with the adjacent 'mountain' and *chhatris* that are positioned at the top. From this vantage point the High Court and Open Hand Monument (designed by Le Corbusier) are visible demonstrating just how close the Rock Garden is to Sector-1. On the right-hand side of the drawing is a theatre with a two-storey pavilion stage area. The watercourse flows underneath the raked seating and suspended stage area. Additional seating is also built into the 'mountain side'.

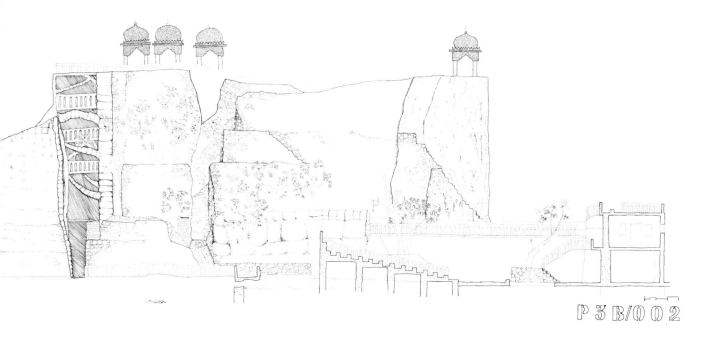

P 3 B/0 0 2

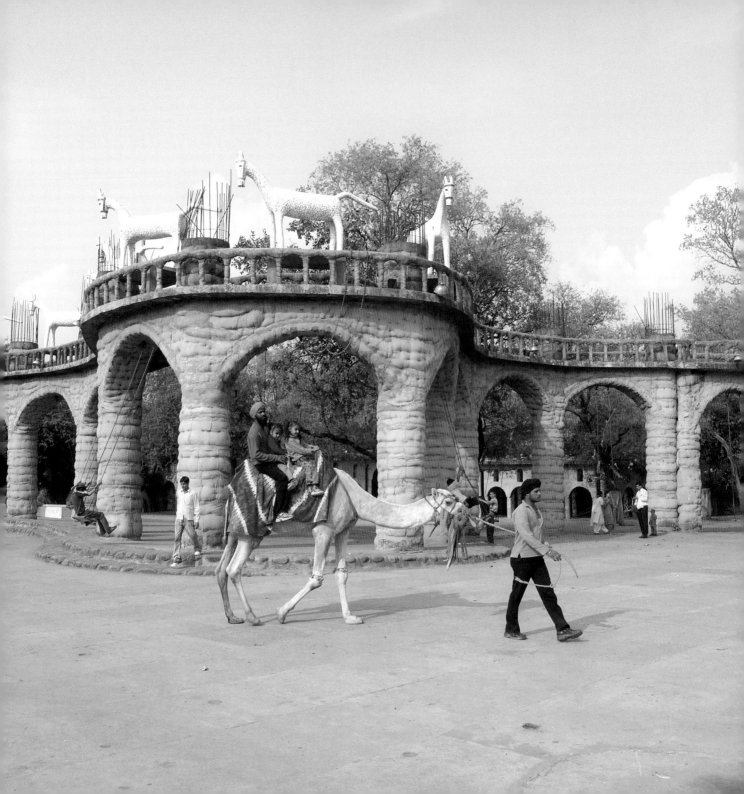

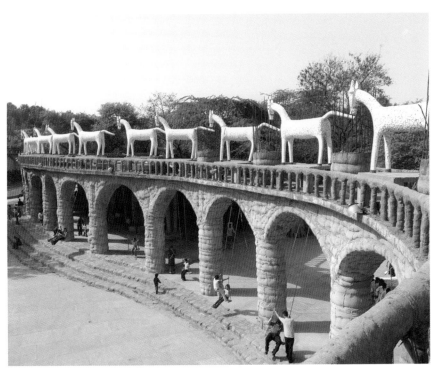

A winding series of columns and arches cuts through the deepest part of Phase-3. Each archway supports a 'family-sized' swing. On top of the archways are large white horse sculptures that were installed from March 2004 onwards. The structure continues into the forest area and is out of bounds to the public at present. It terminates adjacent to the sculpture display and may form an alternative exit route in the near future. The camel is a regular feature of the garden giving rides to families throughout Phase-3.

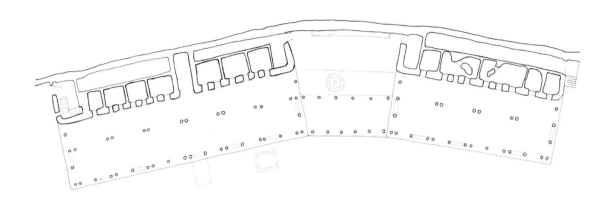

P 3 F

This page spread and next: A series of pavilions make the perimeter wall of Phase-3 habitable. The structures are more formal than the previous structures adopting regular column centres and carefully cast arches. These bear some resemblance to Mughal garden architecture, such as the Diwan-i-Aam and Diwan-i-Khas of the Red Fort in Delhi and Agra. The structures mark a departure from the earlier buildings that sit within the existing topography. In building the structures against the perimeter walls Nek Chand has eliminated the need for a rear façade and subsequently saved materials and construction time.

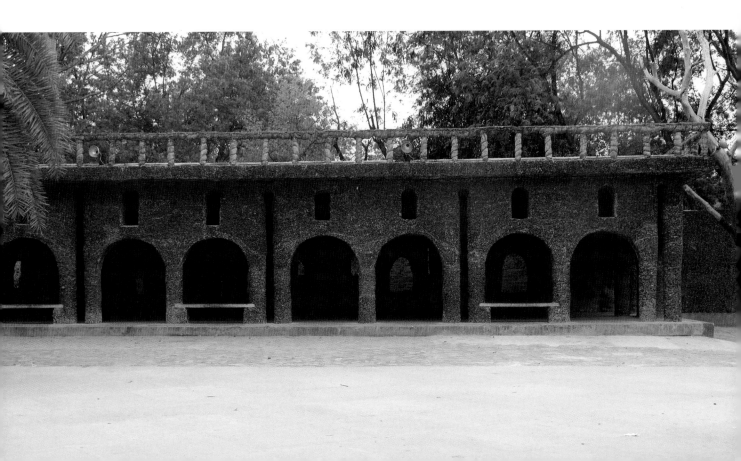

Pavilion containing circus distorting mirrors.
The uniformity of the architecture here
is consistent with the other structures in
Phase-3, but stands out in total contrast to
the previous phases.

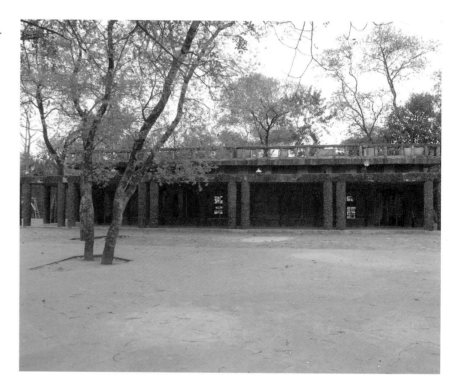

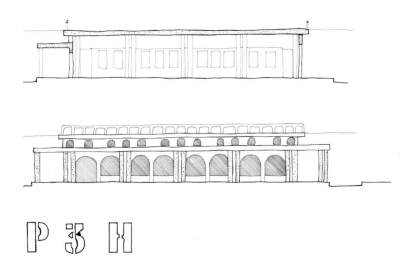

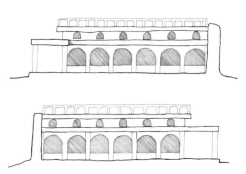

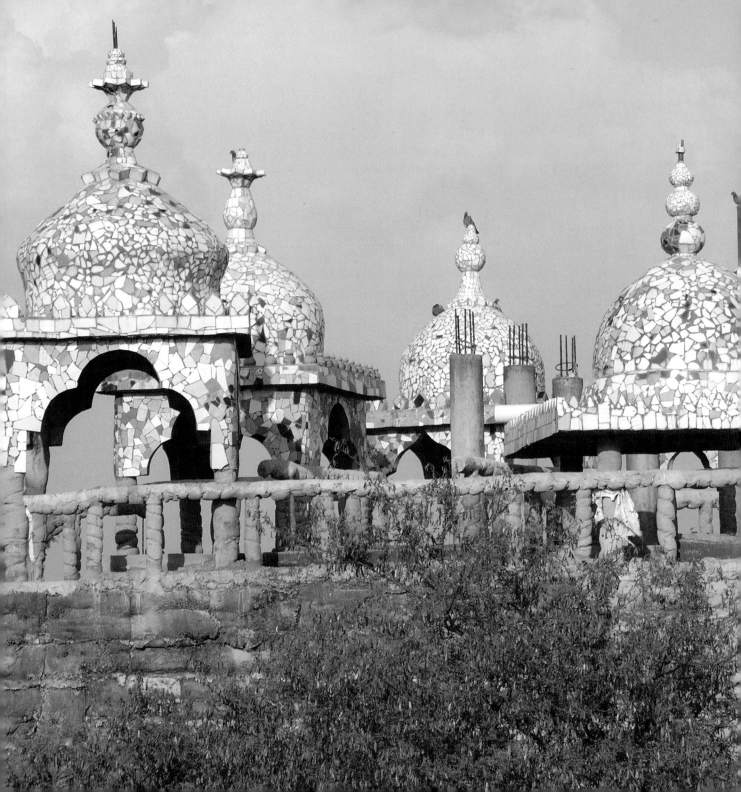

Select bibliography

Ahmed, S. K. (October 20 1989). 'Nek Chand wins battle against lawyers'. *Indian Express*: 3.

Anderson, B. D. (2006). 'Concrete Kingdom: Sculptures by Nek Chand'. *Folk Art* **31**(1-2): 42-49.

Aulakh, M. S. (1986). *The Rock Garden: A panorama of the life-work of Padam Shri Nek Chand*. Ludhiana: Tagore Publishers.

Bahga, S., S. Bahga, et al. (1993). *Modern Architecture in India*. New Delhi: Galgotia Publishing.

Beardsley, J. (1996). 'Garden of Sorrows'. *Landscape Architecture* **86**(9): 139-140.

Beardsley, J. (2003). *Gardens of Revelation: Environments by visionary artists*, London & New York: Abbeville Press.

Beier, U. and P. Cox (1980). *The Kingdom of Nek Chand* (Film for R.M.I.T, Australia). Australia.

Benton, T. (2006). 'Modernism and Nature'. *Modernism: Designing a new world*. London: V&A Publications

Berge, J. T. (1999). *Masters of the Margin*. Zwolle: De Stadshof Museum for Naive Art and Outsider Art.

Bhardwaj, A. (November 4 1991). 'Nek Chand allowed to expand garden'. *Times of India*: pagination unknown.

Bhatti, S. S. (1982). *Rock Garden in Chandigarh: a critical evaluation of the work of Nek Chand*. Queensland: The University of Queensland.

Bhatti, S. S. (1988). 'Rock Garden Di Nek Chand'. *Casabella* **52**(550): 21.

Bhatti, S. S. (1989). 'The Rock Garden of Chandigarh'. *Raw Vision Magazine* **1**: 22-31.

Bhatti, S. S. (1990). 'Rock Garden, Chandigarh'. *Indian Institute of Architects Journal* **55**(2): 31-38.

Bolster, T. (1980). 'An Indian Pop Art Garden'. *Craft Australia* **3**(32 Spring).

Cardinal, R. (1972). *Outsider Art*. London: Studio Vista.

Cardinal, R. (2000-1). 'The Vulnerability of Outsider Architecture'. *The Southern Quarterly* **39**(1-2): 169-186.

Chauhan, U. (3 September 1994). 'Rock Garden: the old and the new'. *The Tribune*. Chandigarh: 19.

CITCO. Undated. *Rock Garden*. Chandigarh: Chandigarh Industrial & Tourism Development Corp Ltd.: no pagination.

Ditzen, L. (1991). *Nek Chand*. Berlin: Haus der Kulturen der Welt.

Evenson, N. (1966). *Chandigarh*. Los Angeles: University of California Press.

Gerrard, N. (1997). 'It's rubbish. But it is art'. *Observer*. London: 7.

Gordon, C. and K. Kilian (1992). *ANQ document - Chandigarh: Forty Years After Le Corbusier*, Amsterdam: Architectura & Natura Press.

Irish, S. (2004). 'Intimacy and Monumentality in Chandigarh, North India: Le Corbusier's Capitol Complex and Nek Chand Saini's Rock Garden'. *Journal of Asesthetic Education* **38**(2): 105-115.

Jackson, I. D. (2002). 'Politicised Territory: Nek Chand's Rock Garden in Chandigarh'. *Global Built Environment Review* **2**(2): 51-68.

Jackson, I. D. (2003). 'Politicised Territory: Nek Chand's Rock Garden in Chandigarh'. *Picturing South Asian Culture in English*. T. Shakur and K. D'Souza (eds.). Altrincham & Liverpool: Open House Press.

Jackson, I. D. (2005). 'Le Royaume De Nek Chand'. *Raw Vision*. **53:** 69.

Jeanneret, P. (1961). 'Aesthetic: Reflections on Beauty of Line, Shape and Form'. *Marg* 15: 56-57.

Kalia, R. (1987). *Chandigarh: The making of an Indian City*. New Delhi: Oxford University Press.

Kapur, V. (2001). *Hybridity: Different moments, diverse effects* (unpublished PhD. Thesis). Pennsylvania: University of Pennsylvania.

Kumar, K. (2003). 'My Heart and soul lives here'. *The Financial World*. Chandigarh.

Lee, J. (2005). *50 Great Adventures*. Prestal.

Lespinasse, P. (2005). Le Royaume De Nek Chand. Film. France: 52 minutes.

Maizels, J. (1997). 'Nek Chand's Rock Garden'. *Raw Vision Magazine* **35:** 23.

Maizels, J. (2000). *Raw Creation: outsider art and beyond*. New York: Phaidon Press.

Maizels, J. (2001). 'Nek Chand 25 years of the Rock Garden'. *Raw Vision Magazine* **35:** 22-31.

Maizels, J. (2003). 'Nek Chand: Creator of a magical world'. A. Carlano (ed.). *Vernacular Visionaries: International outsider art*. Museum of International Folk Art & Yale University Press.

Manley, R. & M. Sloan (1997). *Self-made worlds: visionary folk art environments*. Aperture.

Morris, R. (2000). 'Nek Chand at Kohler Conference and Exhibition'. *Raw Vision* **31:** 20.

Negi, A. S. (2001). 'Nek Chand's Bicycle'. *Raw Vision Magazine* **35:** 29.

Parihar, R. (February 9 1993). 'What ever happened to Rock Garden-III'. *Indian Express:* no pagination.

Peiry, L. and P. Lespinasse (2005). *Nek Chand's Outsider Art: The Rock Garden of Chandigarh*, Flammarion.

Perera, N. (2004). 'Contesting visions: hybridity, liminality and the authorship of the Chandigarh plan'. *Planning Perspectives* **19**: 175-199.

Prakash, V. (2002). *Le Corbusier's Chandigarh: The struggle for Modernity in postcolonial India*. Seattle: University of Washington Press.

Rajer, A. (2000). Nek Chand's Story. *The Folk Art Messenger* **13:** 4-9.

Rajer, A. (2001). Rock Around the Rock Garden in Chandigarh. *The Folk Art Messenger* **14:** 23-25.

Rajer, A. (2005). Another Nek Chand Garden - in South India. *Raw Vision* **53:** 10.

Rajer, A. and D. Paul (2001). Rock Garden Silver Jubilee. *Raw Vision* **35:** 24-27.

Raw-Vision (2000). Nek Chand additions to Kohler Arts Centre. *Raw Vision* **29:** 14.

Raw-Vision (2006). Nek Chand Retrospective. *Raw Vision* **54:** 8.

Rawinsky, G. (2003). 'A Fantasy Land, or the Soul of the City? The Nek Chand Rock Garden, Chandigarh, India'. *The Follies Journal*: 43-52.

Reeve, P. (1994). 'A visit with the Master: The creative genius of Nek Chand'. *Raw Vision Magazine.* **9:** 34-42.

Rhodes, C. (2000). *Outsider Art Spontaneous Alternatives.* London: Thames & Hudson.

Russell, C. (2006). 'Concrete Kingdom: Sculptures by Nek Chand'. *Raw Vision* **55:** 65.

Sarin, M. (1982). *Urban Planning in the Third World : The Chandigarh experience.* London: Mansell.

von Schaewen, D. and J. Maizels (1999). *Fantasy Worlds.* Taschen.

Schiff, B. (1984). 'A Fantasy Garden by Nek Chand Flourishes in India'. <u>Smithsonian</u> **15**: 126-35.

Sharma, M. N. (2001). 'Nek Chand: an early encounter'. *Raw Vision* **35:** 28.

The Tribune (April 24 1990). Nek Chand V's VIP Road. *The Tribune.* Chandigarh**:** 6.

The Tribune (March 29 1992). Spurious Cement stalls work at Rock Garden. *The Tribune.*

Chandigarh**:** 12.

Umberger, L. (2000). *Nek Chand: Healing Properties,* Michael Kohler Arts Center.

The Tribune (November 14 1991). 'Rock Garden sans water for 10 days'. *The Tribune.* Chandigarh**:** 3.

The Tribune Bureau (April 21 1990). 'Part of Rock Garden to be demolished'. *The Tribune.* Chandigarh.

Thukral, R. (October 21 1996). 'Official apathy rocks Rock Garden'. *The Hindustan Times***:** no pagination.

Tribune News Service (September 24 1993). 'Third Phase of Rock Garden opened'. *The Tribune.* Chandigarh**:** no pagination.

Tuchman, M. and C. E. Eliel (*eds.*) (1992). *Parallel Visions: Modern Artists and Outsider Art.* Los Angeles County Museum of Art.

Rock Garden statistics

Location

Adjacent to sector-1, Chandigarh, Punjab.

Natural rocks collected from Sukhna Cho, Patiala Rao and Ghaggar Rivers.

Area of the garden: 18 acres [7.34 hectares]

Perimeter wall: 1095m [3593ft]

Number of sculpted statues: 1621

Number of natural rocks individually displayed: 678

Grand Total of phase 1 and 2: 2335

Number of repaired sculptures: 803

Number of damaged sculptures 321

Sculptures missing: 20

Height of largest waterfall: 15m [49ft] to top of fall, with an additional 4 metres above.

Inauguration of phase 1 and 2:
24 January 1976

An additional inauguration ceremony of the first waterfall area:
10 December 1983

Phase 3 inaugurated on:
23 September 1993

Key dates

1924: Nek Chand Saini is born in a village called Barian Kalan, near Lahore in what is now Pakistan.

1947: India gains Independence from Britain and is divided to create Pakistan. Nek Chand and his family being Hindu abandon their home and move to India.

1951: The construction of Chandigarh begins. Lahore, the old capitol of Punjab was located in Pakistan and so the new Indian capital of Punjab was to be Chandigarh. It was designed by the Franco-Swiss architect, Le Corbusier, his cousin Pierre Jeanneret, Jane Drew and Edwin Maxwell Fry.

1958: Nek Chand begins collecting stones from the surrounding rivers and debris from the destroyed villages.

1972: The garden is discovered by an anti-malarial research party. Nek Chand begins to solicit the support of the chief architect, MN Sharma and other key Chandigarh personnel.

1976: The garden is named the Rock Garden and officially opened on 24 January.

1984: Nek Chand is awarded the title Padam Shri, by the Indian Prime Minister and a postal stamp is produced showing one of the park's sculptures.

1989: A proposal is made by the High Court of Chandigarh to demolish part of the garden to extend their car park and to make a new road. Nek Chand has to fight this proposal in Court and a 'human shield' of Chandigarh residents prevents bull-dozers from demolishing 'Phase-3' of the garden.

Soumyen Bandyopadhyay is a Senior Lecturer at the University of Liverpool, where he is Director of Studies for the Master of Architecture programme. He studied architecture at Calcutta and Liverpool and practises architecture and urban design in Oman, India and the United Kingdom. His research interest lies in the cultural, religious and social practices underpinning architecture in India and Oman. He is the principal investigator of the Arts and Humanities Research Council (AHRC) funded project to study the nature of Modernity in Indian architecture, focusing on the role of the Rock Garden in Chandigarh.

Iain Jackson is currently working towards the completion of his doctoral dissertation on the Rock Garden in Chandigarh. He graduated with a degree in Architecture from the University of Liverpool. He is also a practicing architect who teaches architectural design at the Liverpool School of Architecture.